CHASING THE
ELEMENTS

LIV WILLIAMS

CHASING THE ELEMENTS

THE HEART AND SOUL OF ACTION SPORTS

British Library Cataloguing in Publication Data
A catalogue record for this book is available from the British Library

Chasing the Elements. The Heart and Soul of Action Sports
Maidenhead: Meyer & Meyer Sport (UK) Ltd., 2016
ISBN 978-1-78255-091-4

© 2016 by Meyer & Meyer Sport (UK) Ltd.
Aachen, Auckland, Beirut, Cairo, Cape Town, Dubai, Hägendorf, Hong Kong,
Indianapolis, Manila, New Delhi, Singapore, Sydney, Tehran, Vienna

 Member of the World Sport Publishers' Association (WSPA)

Manufacturing: Print Consult GmbH, Munich
E-Mail: info@m-m-sports.com
www.m-m-sports.com

CONTENTS

THANK YOU TO

John, Melanie, Sorcha, Tamzin, Iwan, William, and Hero. The constant enthusiasm.

The Oxford commas. The laughter. The love. Chrissy Grant. The friendship. The perspective.

Laura Corso. The wanderlust. The FaceTime. Ben Selway. The unquestioning generosity.

Meyer & Meyer Sport. The opportunity. The Athletes. Your candid responses.

Sorcha Williams. The sub-editing. Matt Meyerson. You hooked me up!

Thank you | CHASING THE
ELEMENTS

INTRODUCTION

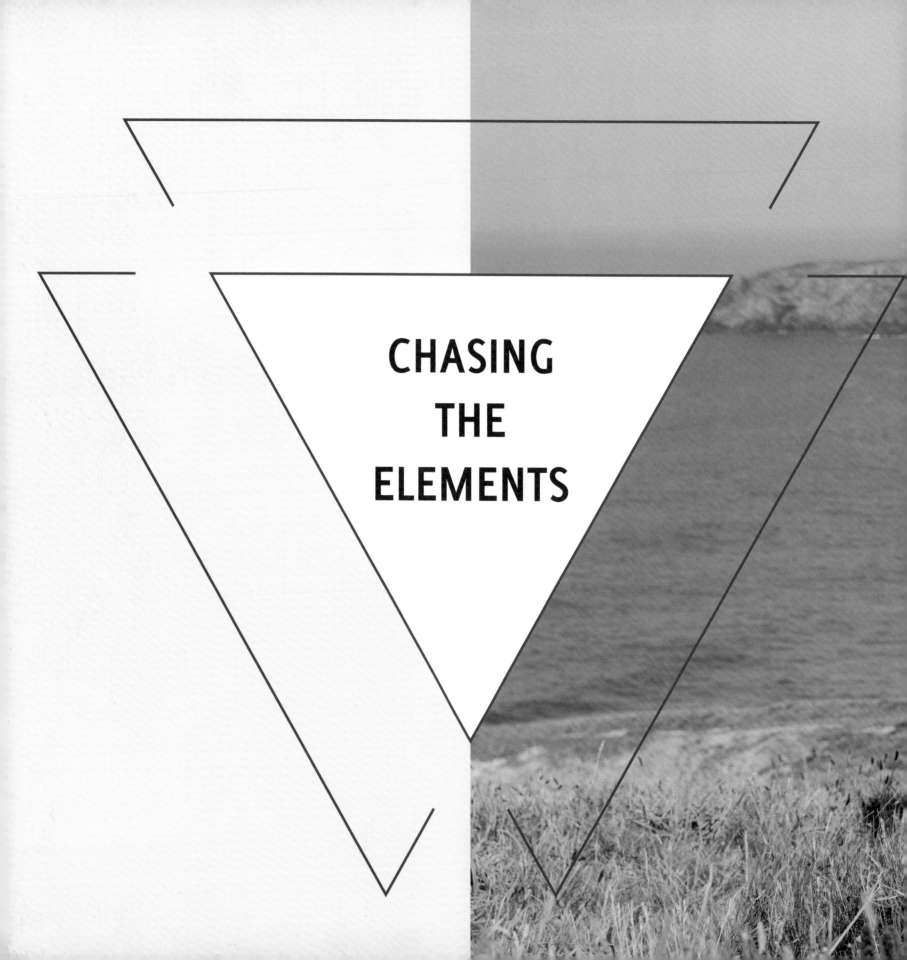

CHASING
THE
ELEMENTS

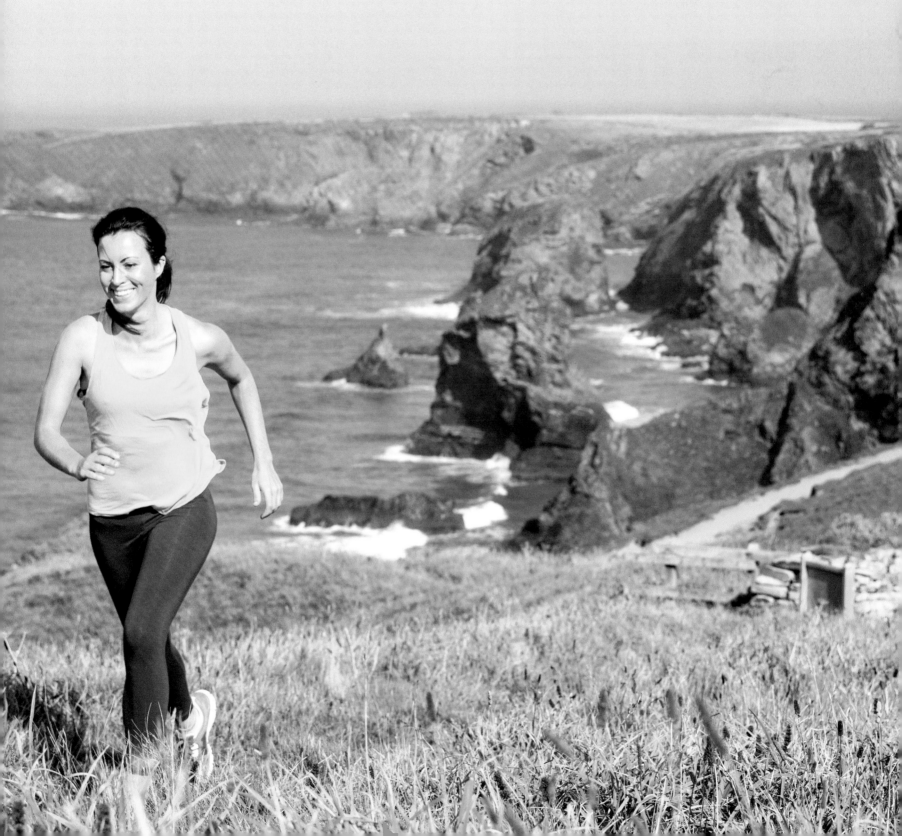

I've been an outdoors creature all my life. I've doused stresses, hardships and moments of clarity and elation with equal doses of wilderness, travel and action.

I've found myself in hostile situations in the newly-formed Slovakia when I was seventeen whilst attempting to get to the Tatra Mountains to climb and snowboard; I've paddled back to land from an offshore reef where I'd been bitten and made to bleed by 'something' in the water while surfing; I've motorbiked through the bush at night where machete-wielding gangs reside. I've twice won triathlon championships by training in all elements in the Welsh mountains, racing 200 other athletes during the 1.5K swimming leg in a peat-laden lake during a storm in North Wales, falling into mountain ditches whilst still clipped into my road bike, swimming against the tide and alongside a passenger ferry in the Irish sea.

I love the feeling of being present, at any given moment, with complete awareness of my physicality.

This background and my profession as a conflict zone and natural disaster filmmaker has conditioned me to conduct my life with drive, fast decision-making, self-awareness and honesty. I've filmed at ground zero in the Philippines after Typhoon Haiyan, refugee camps in Iraqi Kurdistan, Zero Point in Turkey and the Syrian border where communities continue to flee from Daesh (aka, ISIS). I've worked through aftershocks in Nepal after the deadly earthquakes.

The backdrop to my life has been my extreme sports blog, www.iLivExtreme.com, which has been a gateway for me to speak with and listen to athletes and adventurers who possess the same compulsion to test themselves in all natural environments and push themselves until their bodies and souls are on fire.

What I've learned is that ego plays a part, but it's also about self-awareness, candour and focus.

I've always felt that there's an invisible wire connecting my body to the great outdoors, to testing my physical endurance and back to my perception of self. I've come to learn that there's incredible strength in vulnerability; make it your friend. Be comfortable with it showing up unannounced and staying a while. If you can master this, with all of the roses and thorns that it can create inwardly and outwardly, you've succeeded; you're living in the moment.

Throughout this book, you'll notice that I've included featured photographs by the incredible action sports photographer Ben Selway. I'm very lucky in that I am able to call upon Ben and his wife Hawk, both great friends. Not only are they both survivors of life's tribulations, but they've learned to enjoy each moment, appreciate the simple things and to live well. Ben's love of the

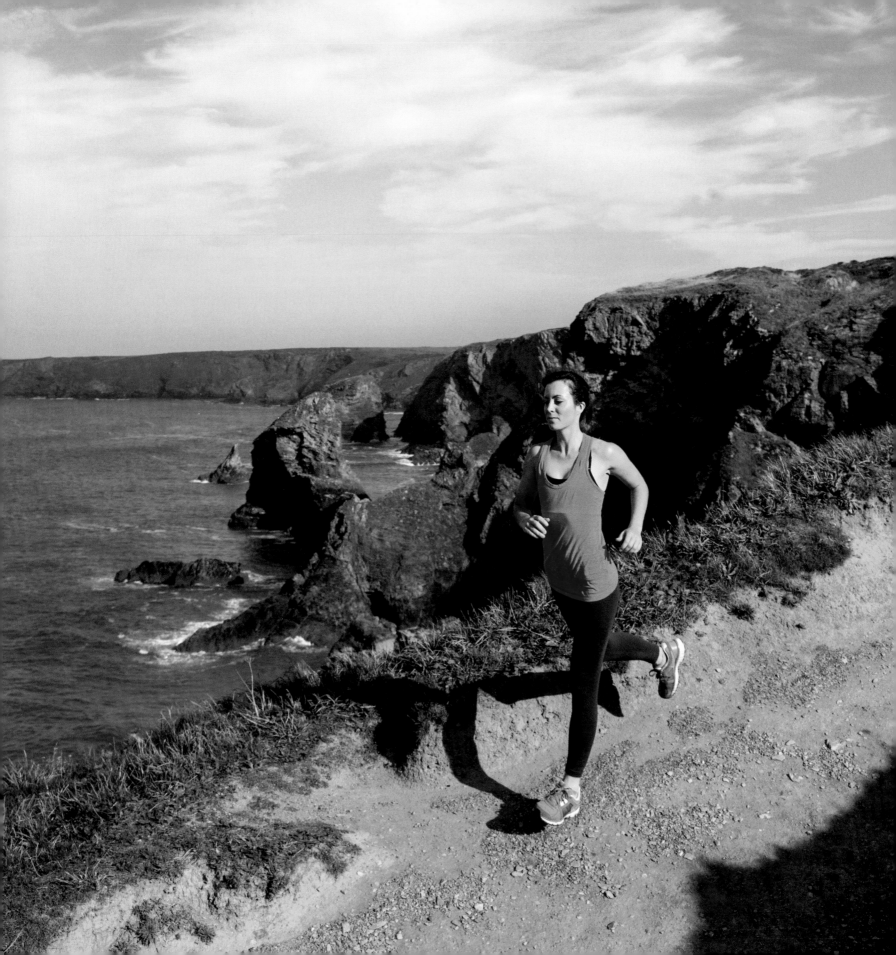

ocean, vast landscapes and skies casts a light onto how beautiful our planet is.

We must explore and enjoy it, but in so doing recognise that we owe our world compassion; replenish its energies, adore its expanses and do right by it.

Thanks for reading, and enjoy the book

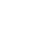

SOCIAL

WEB	WWW.ILIVEXTREME.COM
TWITTER	@ILIVEXTREME
LINKEDIN	WWW.LINKEDIN.COM/IN/LIVWILLIAMS

INTERVIEW

TIA BLANCO
PRO SURFER

"If it's your time to shine, then
nature will provide,
and if it is someone else's,
then that's how it goes."

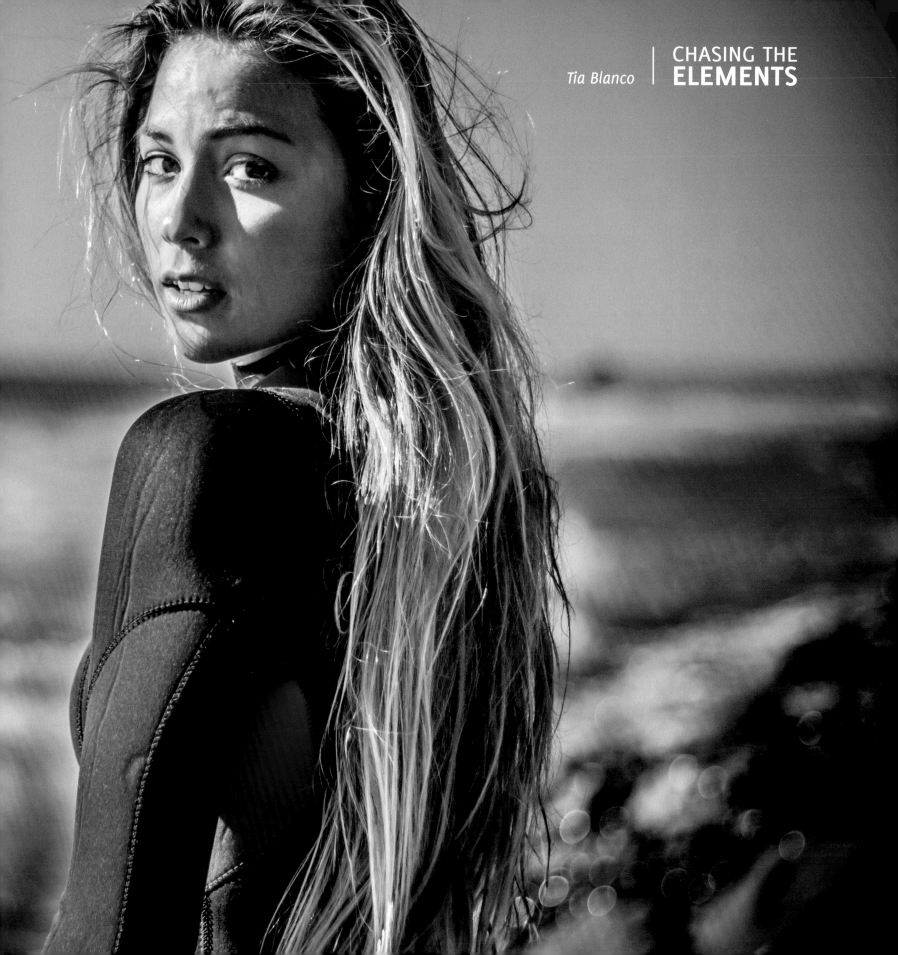

CHASING THE
ELEMENTS | *Tia Blanco*

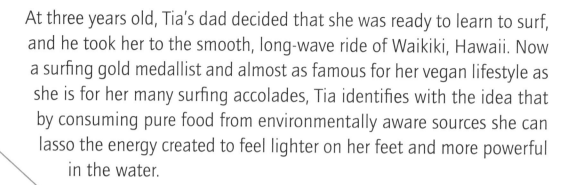

At three years old, Tia's dad decided that she was ready to learn to surf, and he took her to the smooth, long-wave ride of Waikiki, Hawaii. Now a surfing gold medallist and almost as famous for her vegan lifestyle as she is for her many surfing accolades, Tia identifies with the idea that by consuming pure food from environmentally aware sources she can lasso the energy created to feel lighter on her feet and more powerful in the water.

Now a Surfing America team rider and committed to competing all over the world, Tia was found on Instagram by the creative director at Reef who immediately offered to sponsor her, and then other sponsors followed. She surfs every day except when there's no swell, then she hikes. And as the sun sets and she turns her attentions to mindfulness and clarity, she paints.

Having recently returned from the British Virgin Islands where she was on a shoot for *Surfing* magazine, Tia is excited at having just seen New York City from the air, which she describes as *"incredible."* I ask her if she enjoys being in front of a camera: *"I think that the more photoshoots and interviews I do, the easier it gets. I remember when I was younger I would get so terrified to do live interviews, but now I am a little more used to it, even though I still get a little bit nervous."*

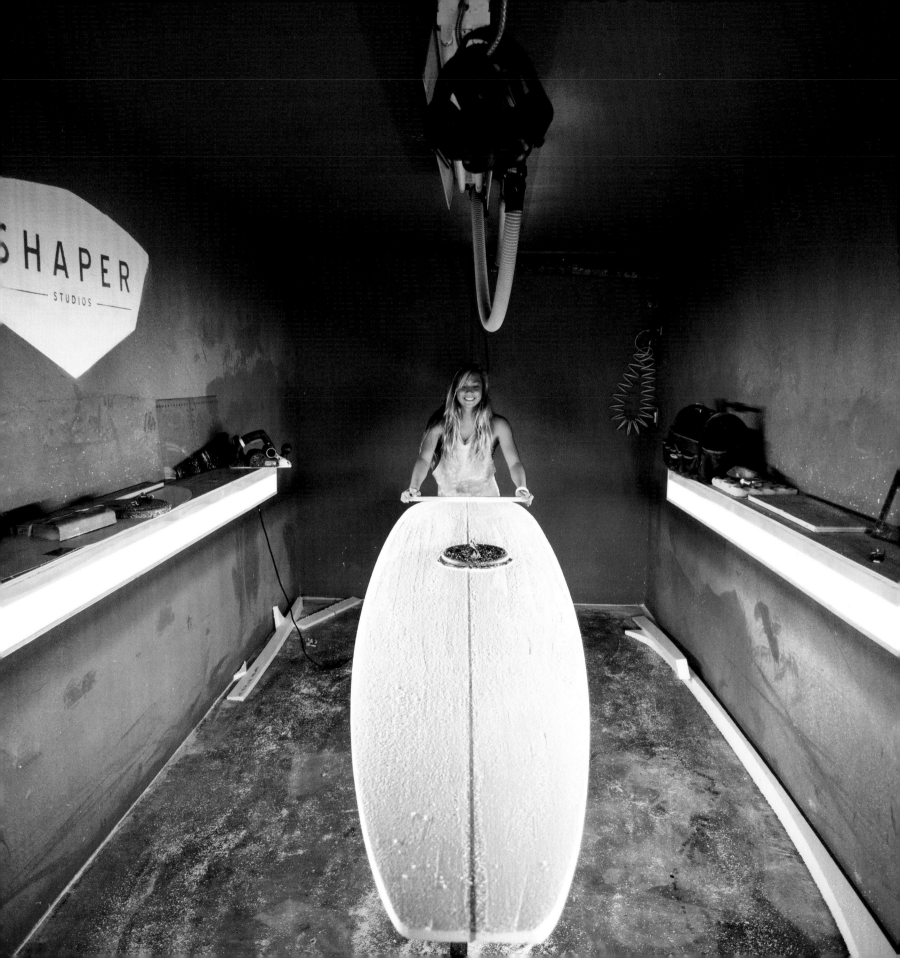

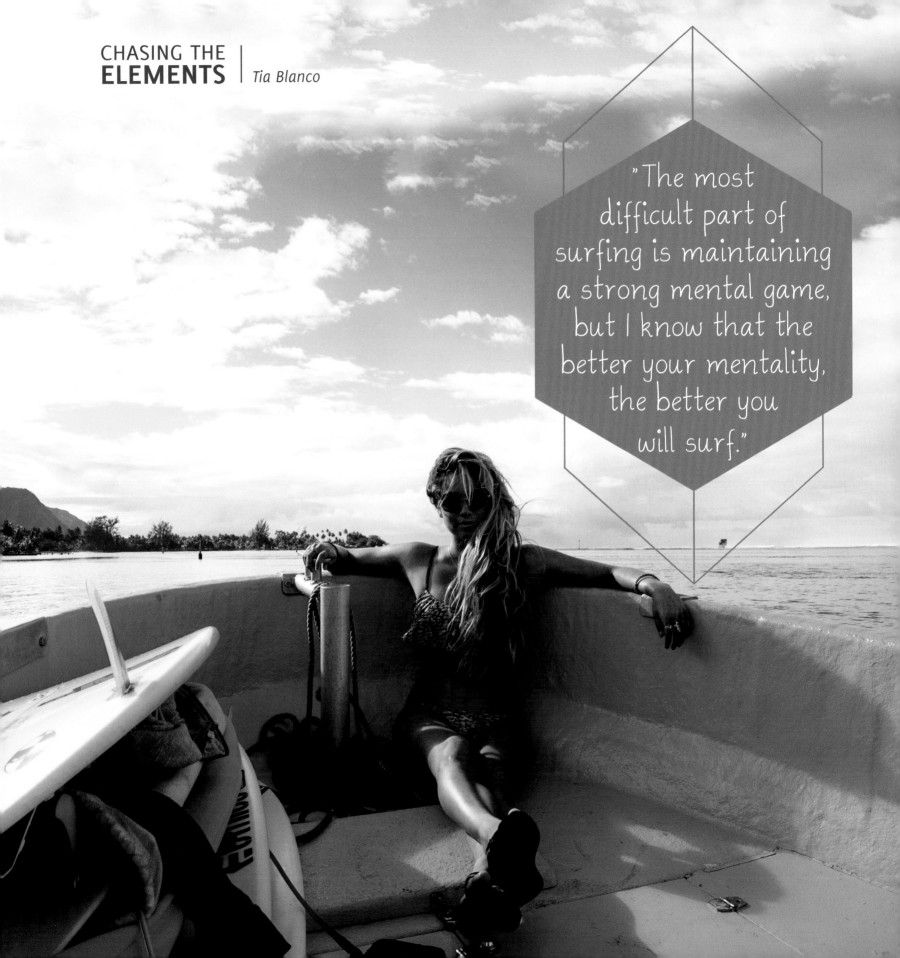

"The most difficult part of surfing is maintaining a strong mental game, but I know that the better your mentality, the better you will surf."

What does a typical day look like for you?

It involves surfing, doing hot yoga or training, and eating lots of fruits and veggies. I also love to cook vegan meals for my family.

You've been super busy of late; what are you most proud of from the past 12 months?

Winning the 2015 ISA World Surfing Games women's gold medal.

Wow, and next year, what's on the agenda?

Travelling around the world to compete in the qualifying series events and hopefully making the world tour!

What drives you to surf every day?

I really just love being in the ocean. As cheesy as this sounds, everything just feels right when I am in the water and surfing. For me, the most difficult part of surfing is maintaining a strong mental game, but I know that the better your mentality, the better you will surf.

If you weren't a pro surfer, what do you think you'd be doing instead?

This question is hard! I couldn't imagine life without surfing, my whole world revolves around it. I like to surround myself with people who have the same interest

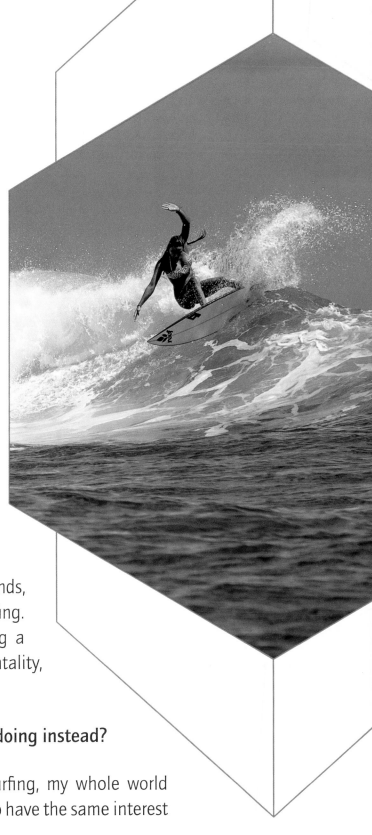

as me, but they don't necessarily have to be surfers. I'm also very passionate about health. I find that a lot of people I hangout with usually love the ocean, eating healthy, and staying active, so I guess I would maybe go to cooking school and start a vegan restaurant!

Tell me about where you grew up and how you were raised?

I am a military brat! My family and I move around every three years. I have lived in Puerto Rico, Hawaii, and all over California. I am currently residing in San Diego, but my favorite place to surf is Tahiti because the waves are so perfect, and I love surfing in the tropics. I love the healing power of the ocean; it soothes my soul. My parents have always encouraged me to put 110% into everything I do. My favorite childhood memories are all tied up in the trips my family would take to the beach. We'd have all-day beach days in Hawaii. My dad would rally up the family, and we would spend the whole day surfing, swimming, and running around on the beach. My mom loves photography, so she would always take photos of us all surfing and having fun.

Do you think that coming from a military family has helped shape you or your career in any way?

I think it has made me adapt to things more easily. It was definitely hard for me to start all over again with my social life and move to a new location, but in some ways I think it made me a stronger person.

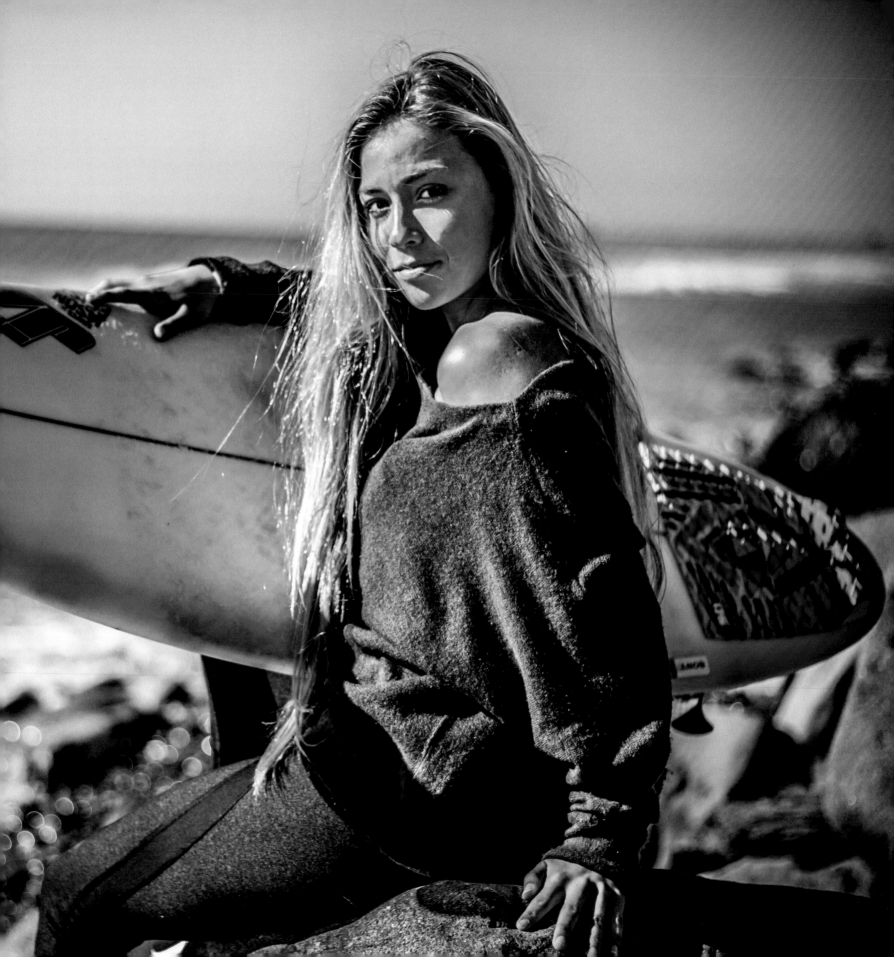

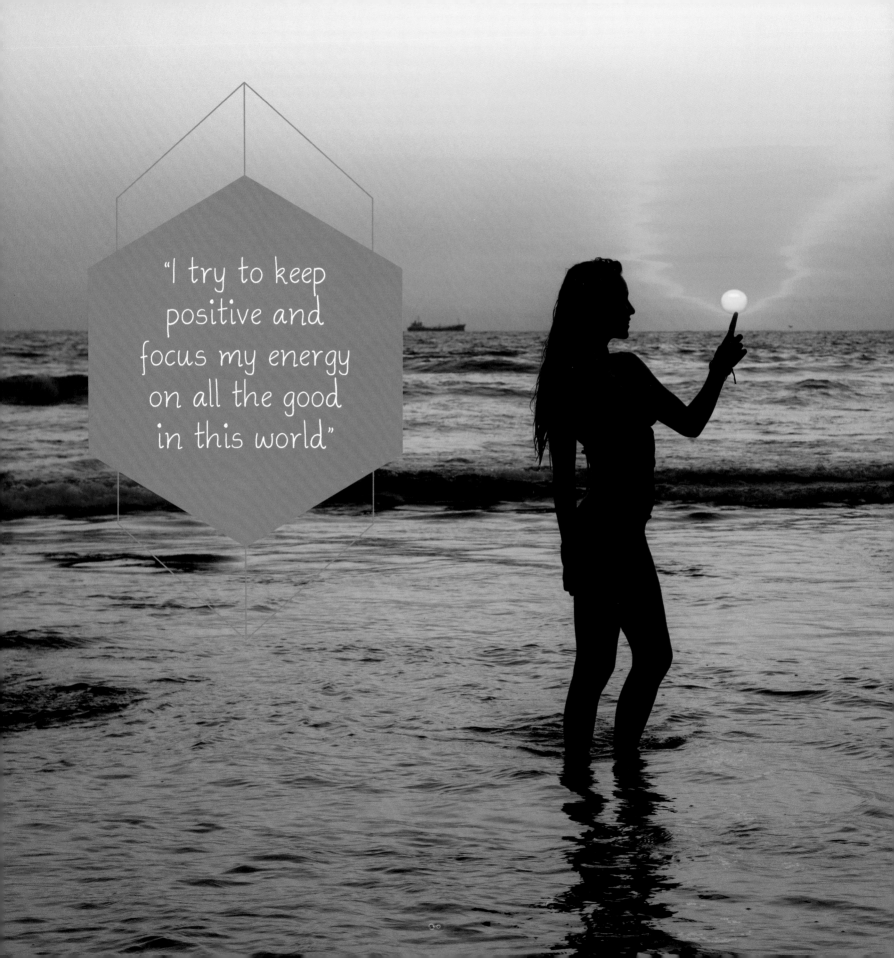

"I try to keep positive and focus my energy on all the good in this world"

Where in the world would you like to go and get lost for a while?

If I was ever at a point in my life where I was just way too stressed out or something, I would move to Bali for six months. I feel like Bali is one of the most spiritual and healing places out there, doing yoga retreats, surfing, and eating yummy food would do the trick! But then I have never surfed Fiji before, so it is definitely on the bucket list as it looks absolutely incredible.

What other sports do you like to do?

Is yoga a sport? I love yoga, particularly the way it makes me feel physically and mentally.

Anything you wish you'd realised about yourself sooner?

I learned that giving makes me so happy, giving love to others is so fulfilling. For me, the feeling you get when you give to others is better than receiving.

What would you like to achieve with your surfing career?

I just want to keep progressing in my surfing and make the Championship Tour.

What do you think draws people to action sports?

I think it is just really fun to have someone or something to root and stand for! Everyone has their favorite athlete or team out there, and it is cool to see your favorites succeed.

Nature plays a huge part in what you do; what kind of relationship do you have with nature?

I personally do not believe in luck or coincidence. If it's your time to shine, then nature will provide, and if it is someone else's time, then that's how it goes. Everything happens for a reason.

What is it that makes you most sad?

There are so many horrible things currently happening in this world that make me sad, from world hunger, the struggle with women's equality, racism, war, the billions of animals dying every year for human pleasure. It's really easy to dwell on all of those things and get bummed out, so I try to keep positive and focus my energy on all the good in this world.

Who do you most admire?

I admire many people. I just finished watching a documentary on Malala Yousafzai, the Pakistani activist for female education and the youngest-ever Nobel Prize laureate. Her story is remarkable.

What is it about your lifestyle that you value the most?

Being vegan is a lifestyle that I would never give up. I am so thankful to be able to eat healthy every day. I value what veganism stands for, and that is love and compassion. The benefits are literally endless.

SOCIAL
TWITTER & INSTAGRAM @TIA_BLANCO

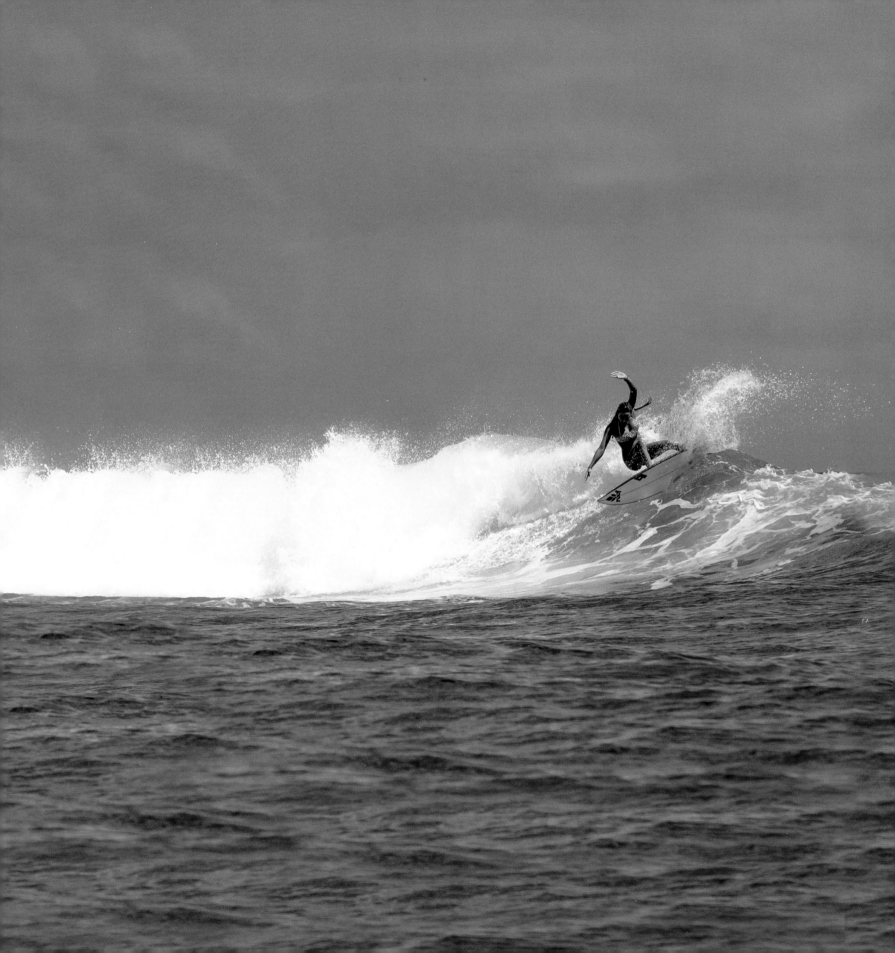

INTERVIEW

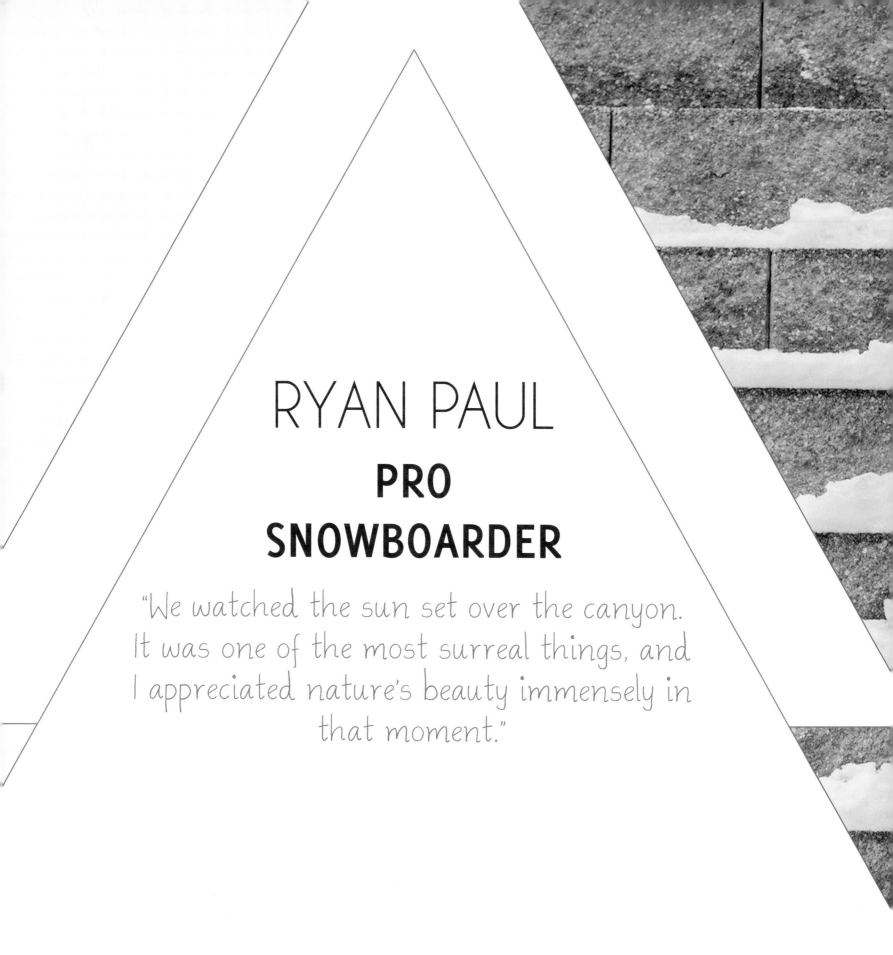

RYAN PAUL

PRO
SNOWBOARDER

"We watched the sun set over the canyon. It was one of the most surreal things, and I appreciated nature's beauty immensely in that moment."

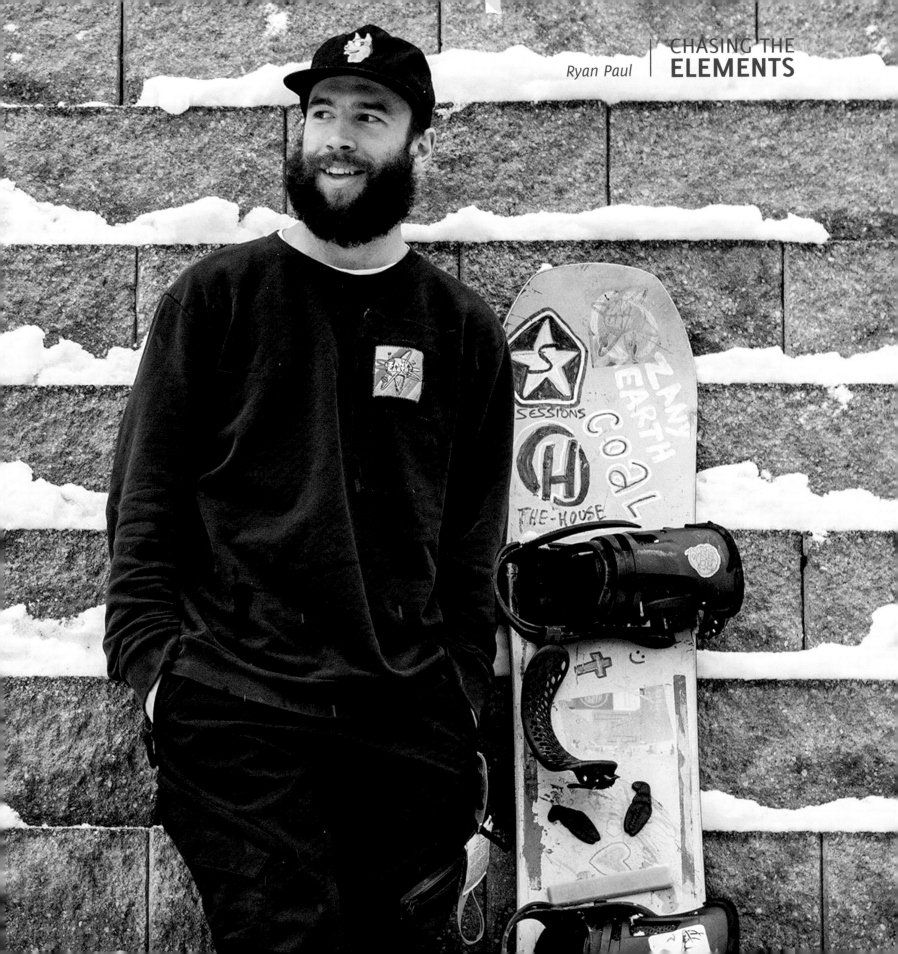

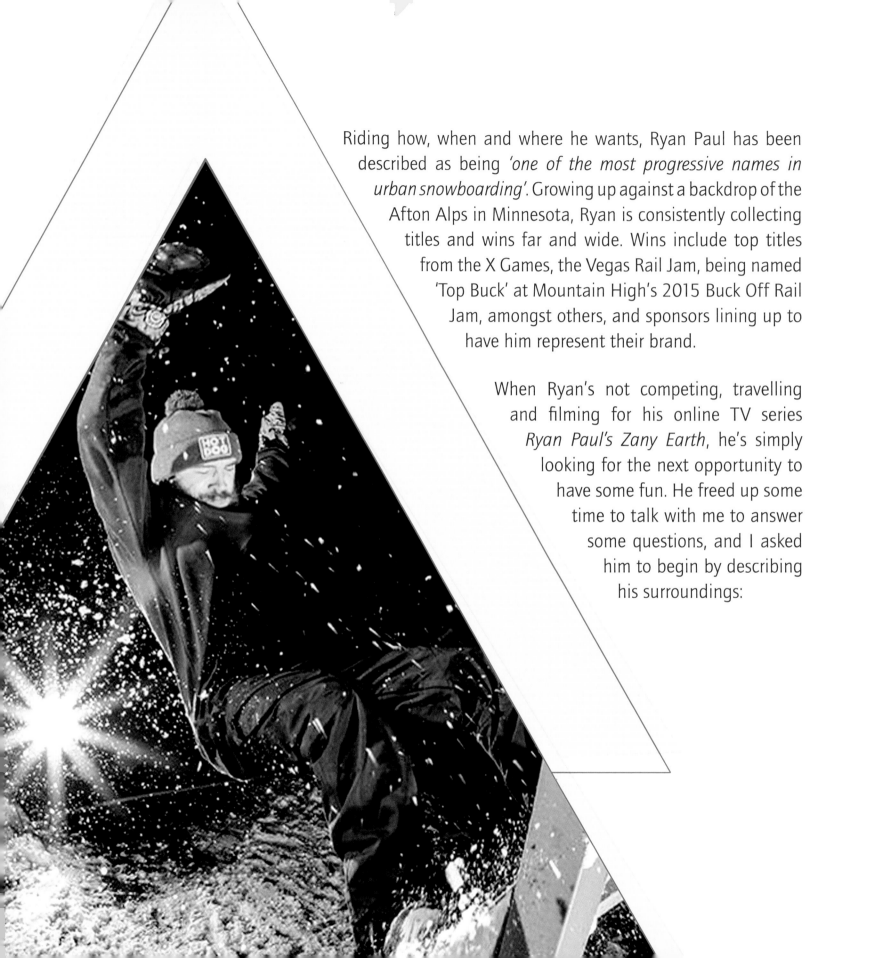

Riding how, when and where he wants, Ryan Paul has been described as being *'one of the most progressive names in urban snowboarding'*. Growing up against a backdrop of the Afton Alps in Minnesota, Ryan is consistently collecting titles and wins far and wide. Wins include top titles from the X Games, the Vegas Rail Jam, being named 'Top Buck' at Mountain High's 2015 Buck Off Rail Jam, amongst others, and sponsors lining up to have him represent their brand.

When Ryan's not competing, travelling and filming for his online TV series *Ryan Paul's Zany Earth*, he's simply looking for the next opportunity to have some fun. He freed up some time to talk with me to answer some questions, and I asked him to begin by describing his surroundings:

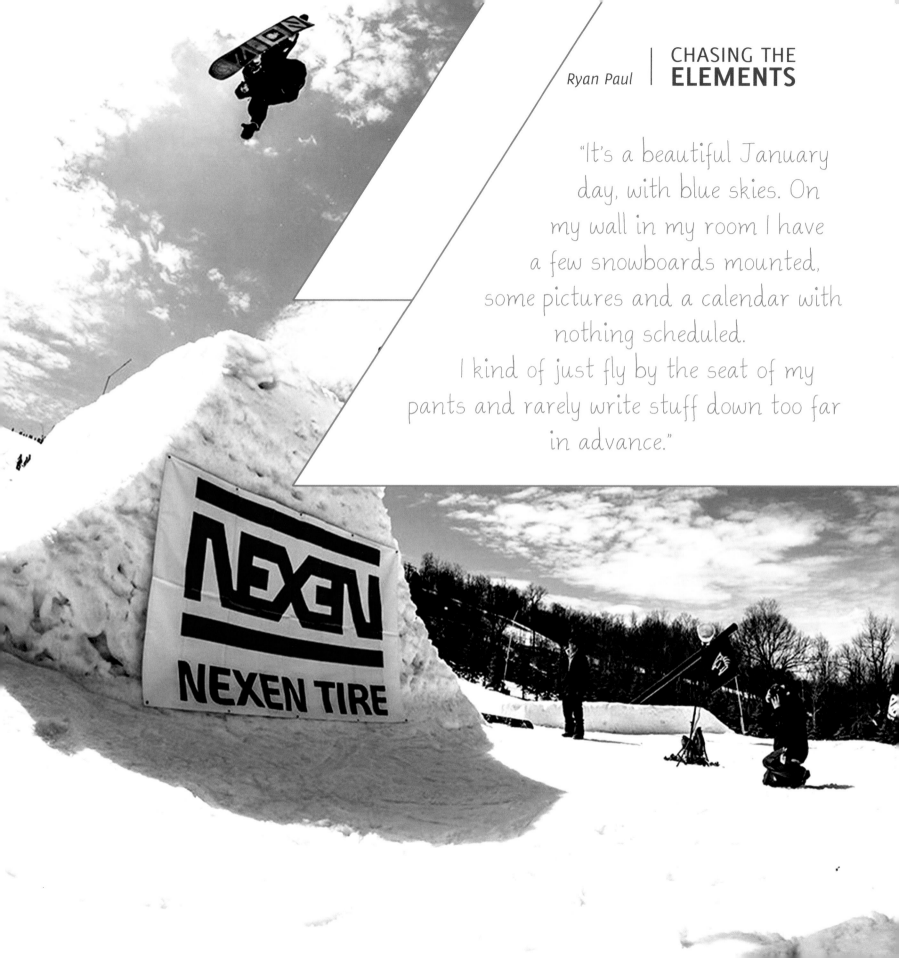

"It's a beautiful January day, with blue skies. On my wall in my room I have a few snowboards mounted, some pictures and a calendar with nothing scheduled. I kind of just fly by the seat of my pants and rarely write stuff down too far in advance."

CHASING THE
ELEMENTS | *Ryan Paul*

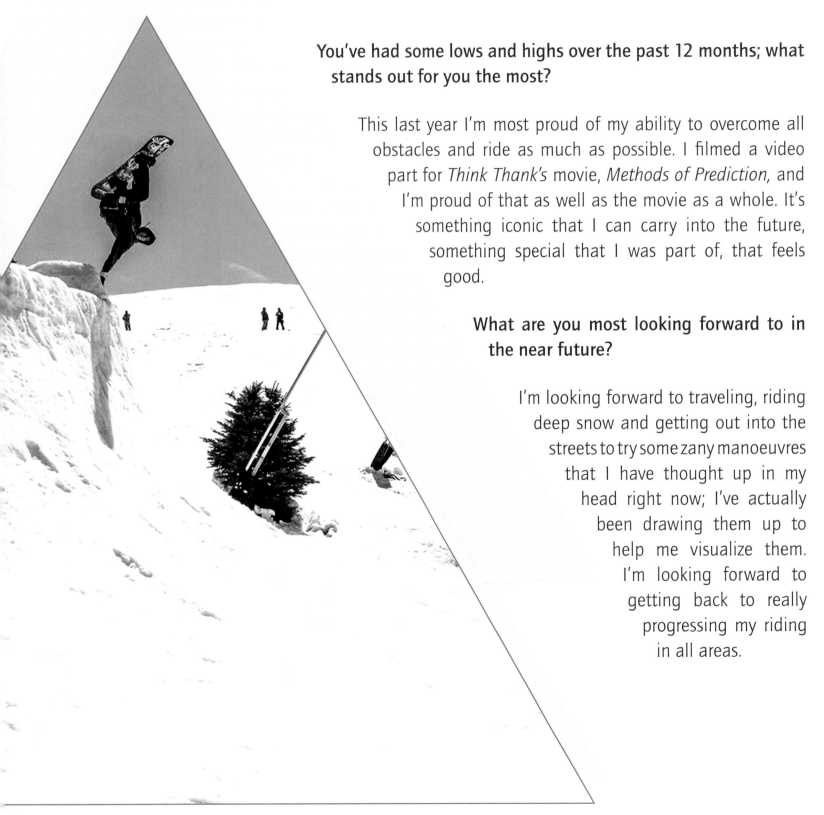

You've had some lows and highs over the past 12 months; what stands out for you the most?

This last year I'm most proud of my ability to overcome all obstacles and ride as much as possible. I filmed a video part for *Think Thank's* movie, *Methods of Prediction*, and I'm proud of that as well as the movie as a whole. It's something iconic that I can carry into the future, something special that I was part of, that feels good.

What are you most looking forward to in the near future?

I'm looking forward to traveling, riding deep snow and getting out into the streets to try some zany manoeuvres that I have thought up in my head right now; I've actually been drawing them up to help me visualize them. I'm looking forward to getting back to really progressing my riding in all areas.

What does a regular day look like for you?

I wake up, check a few things off the morning "to do" list, drink coffee, shower, brush teeth. Today I went snowboarding. I try to ride a board of some sort every single day. Some days its skateboarding or surfing, like in the summer; all throughout the winter its snowboarding! Tonight I'm going to go shoot pool with some friends; this past year I've gotten pretty into pool!

What motivates you to head out snowboarding?

It's fun! it feels good to be cruising around on a snowboard. It can do a lot of things for me. It can be something that relaxes me or something that gets me amped up!

"There's difficulty in doing exactly what you want to do, but it's way worth it."

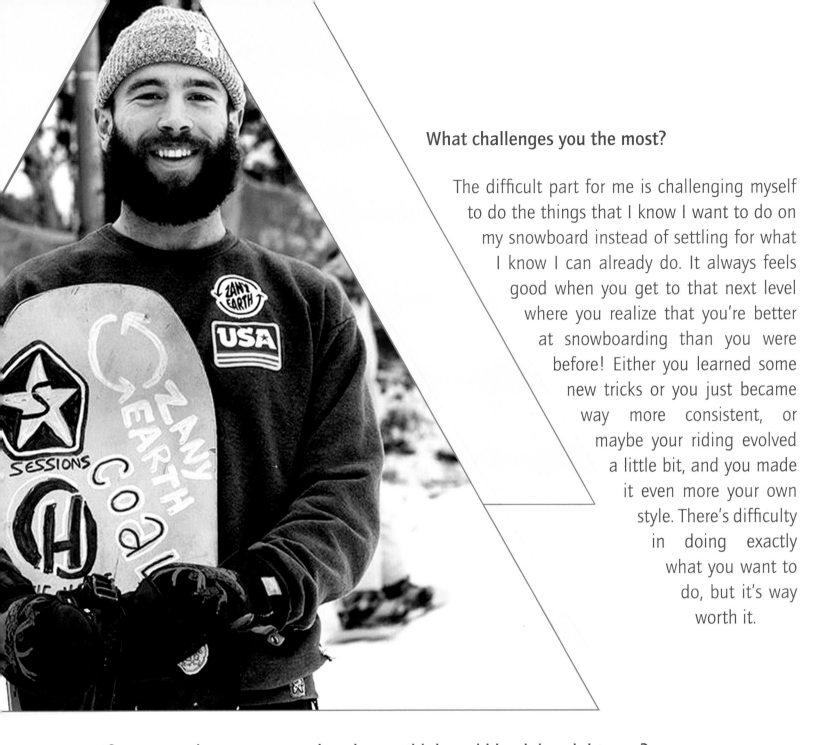

What challenges you the most?

The difficult part for me is challenging myself to do the things that I know I want to do on my snowboard instead of settling for what I know I can already do. It always feels good when you get to that next level where you realize that you're better at snowboarding than you were before! Either you learned some new tricks or you just became way more consistent, or maybe your riding evolved a little bit, and you made it even more your own style. There's difficulty in doing exactly what you want to do, but it's way worth it.

If you weren't a snow pro, what do you think you'd be doing right now?

I like to skateboard, surf, bike, play pool, and frisbee golf, but I'd probably be doing something artistic. I would love to be a painter or work with clay; pottery interests me.

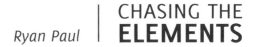
Name an extreme sports activity you'd like to try and why?

Wind surfing. I think it would be insane!

How were you raised?

I grew up in Cottage Grove, Minnesota. It's a suburb of St. Paul, the capital. Cottage Grove has about 40,000 people living there. It's cold in the winter and hot in the summer, and everyone likes to be outside a lot. The people have always been really nice. I grew up with three other siblings, and my parents always looked out for us and wanted us to grow up good, so they took us to church every weekend and taught us to be honest and to have other values that would help us in life. My dad and mom always made sure that we were doing what we loved, so when I got into snowboarding they bought me a season pass and drove me out to Afton Alps, the local ski area, every weeknight after school and let me ride all day on the weekends.

... and the happiest moment in your career so far?

When I went to the North Island of Japan when I was 21 we hiked up this volcano full of snow. When I got to the top and got to look out at all the beauty that I could see, that was the happiest moment of my career. I still can hardly believe all the great places that snowboarding has taken me, and Japan was one of the most amazing.

What's the most important lesson your parents taught you?

Probably just to be honest. I think that's important. Be honest. "To thine own self be true." My parents also taught me to pray, and they taught me about God. I think that teaching me these things helped me a lot. Trying to be truthful with others just helps in every area of life. Having a higher power definitely takes a lot of the stress out of my equation. I think God cares

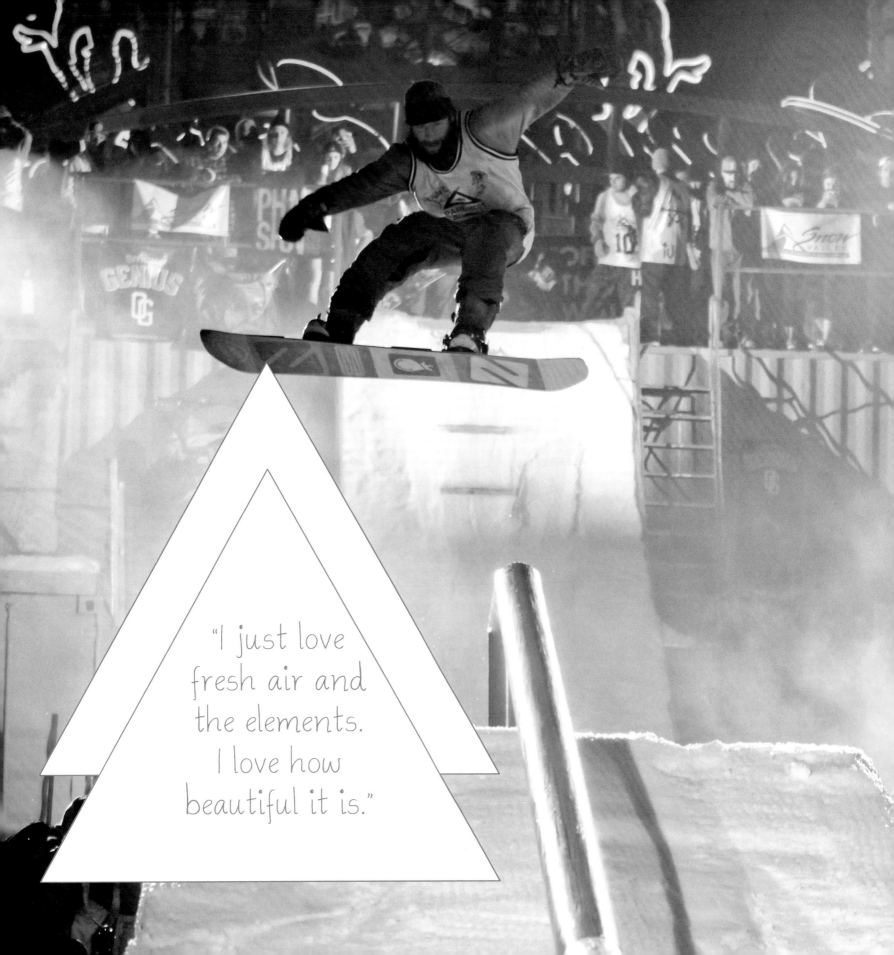

"I just love fresh air and the elements. I love how beautiful it is."

about me and he cares about everyone, and even though bad things happen, he's always there to get us through good times and bad.

What do love the most about being out in the great outdoors?

I just love fresh air and the elements. I love how beautiful it is. I get inspired when I'm outside and when I'm active and having fun.

Where would you like to explore?

I think the USA. There is so much of the country I still haven't experienced!

Tell me about one of your favourite childhood memories.

When I was young my family took a two-week road trip across the US and Canada. It was a lot of driving and site seeing; we went to some cool places and met some awesome people.

So since that road trip and being a kid, what have you learned about yourself?

This isn't really about me, but I learned that you can take your time with things, particularly relationships. I wish I would have learned that the easy way, but I'm happy where I'm at now. I had to go through hell and high water to figure out to just take it easy, pace myself and not rush into things, and hopefully this lesson will benefit me in the future, keep me grounded, and help me make good choices as far as relationships go.

"I had to go through hell and high water to figure out to just take it easy, pace myself and not rush into things."

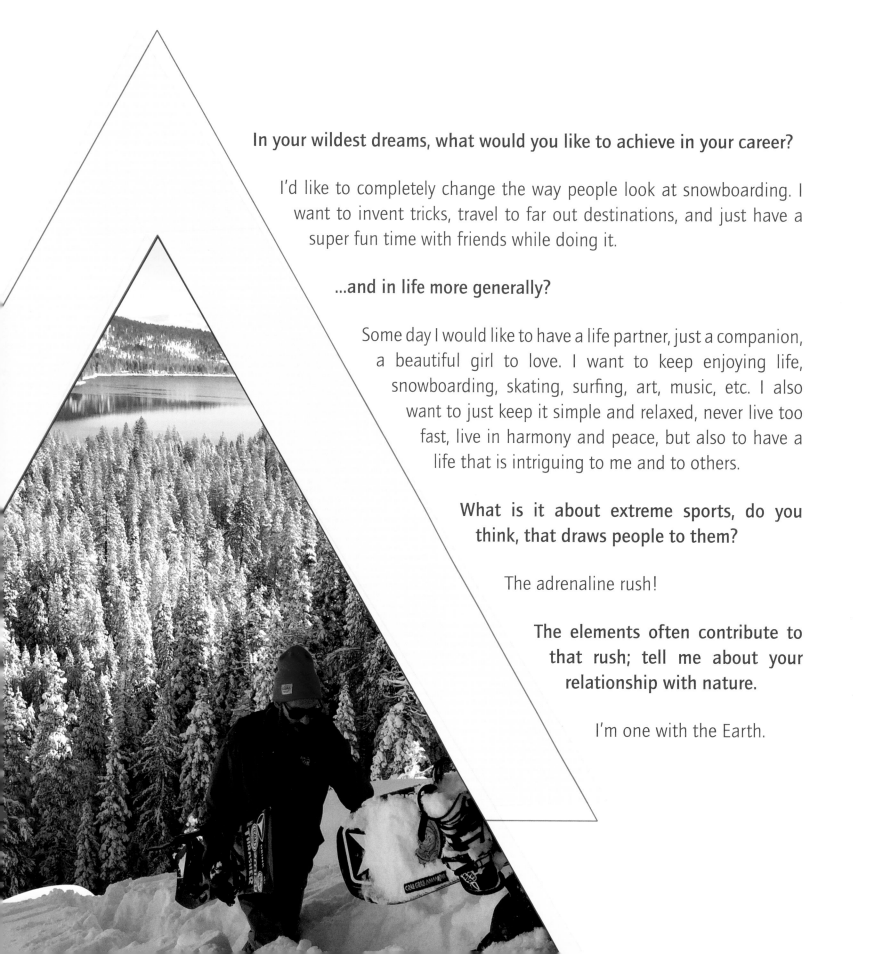

In your wildest dreams, what would you like to achieve in your career?

I'd like to completely change the way people look at snowboarding. I want to invent tricks, travel to far out destinations, and just have a super fun time with friends while doing it.

...and in life more generally?

Some day I would like to have a life partner, just a companion, a beautiful girl to love. I want to keep enjoying life, snowboarding, skating, surfing, art, music, etc. I also want to just keep it simple and relaxed, never live too fast, live in harmony and peace, but also to have a life that is intriguing to me and to others.

What is it about extreme sports, do you think, that draws people to them?

The adrenaline rush!

The elements often contribute to that rush; tell me about your relationship with nature.

I'm one with the Earth.

Can you elaborate?

Just recently a friend and I went to the Grand Canyon. He had never been there, and we hiked around these cliffs and found some rocks to hang out on. We drank beer and watched the sun set over the canyon. It was one of the most surreal things, and I appreciated nature's beauty immensely in that moment; it kind of just washed over me.

"I appreciated natures beauty immensely in that moment; it kind of just washed over me."

Who do you most admire and why?

Rodney Mullen. He is a pro skater and the inventor of a whole different style of skating that none could replicate. He's a second-to-none innovator, and his passion cannot be measured.

If I asked you to shut your eyes and go to your 'happy place', tell me what we'd see.

A beautiful ocean. There's this girl, her name's Emily. She's there. The town is San Clemente right now, but it could be any beach town. For some reason at this time in life my happy place is there. It's a physical place, and I have memories from this past summer, spending time on the beach with my friend Emily. She's really wonderful, and anywhere with her is my happy place.

SOCIAL

TWITTER @THEREALRYANPAUL

REFLECTION

THE CHASE

When I was a kid, the name 'action' or 'extreme' sports didn't exist. Sure, I was heading into the mountains, climbing up cliffs so that I could jump into deep torrents of water below, or making up physical challenges with my sisters that could easily have ended in nasty injuries, but we would be told to stop or were chased from private land, and that was part of the allure.

For us and previous generations, this was just called 'childhood'. But in my teens, sports began to emerge that automatically gave the performer a cool identity. Suddenly it wasn't enough to screw some wheels onto a plank of wood and ride it down the hill, or as I used to do up on a neighbouring farm in mid-Wales, find some animal feed bags, fill them with straw, point them down a snow-covered hill, stand on them and hurtle to the bottom. Professional equipment started to appear in the vicinity, and before long, everyone's older brother owned a skateboard or was disappearing to the Alps to ride their board on the all-hallowed and much revered powder.

People who participated in the action sports lifestyle were labelled as delinquents or reprobates who would never amount to anything. They were chastised for their guerrilla-style 'borrowing' of public spaces; skating in empty private swimming pools, toying with death by longboarding down the skein of roads with on-coming traffic, jumping from high-rise buildings, only to release a parachute at the last minute, land and then disappear into the crowd.

The nerve and attitude to push physical boundaries and overcome fear is deeply entrenched in all action sports and has captured attention all over the world. Now, only a few years after the term 'action sports' was first coined, professional action sports athletes are making millions of dollars. Companies are spending hundreds of millions to submerge into the action industry, and consumers are spending billions of dollars to take home a slice of the identity, personified by those late-nineties 'slackers'.

INTERVIEW

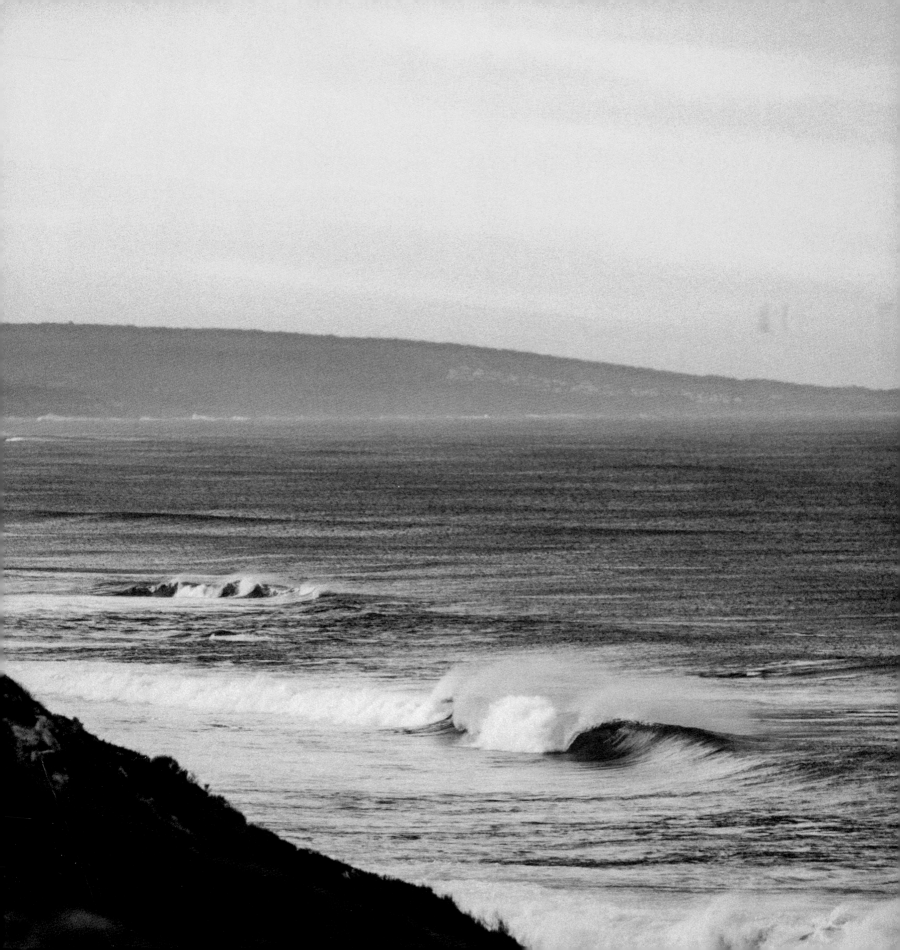

BRETT NOVAK

ACTION SPORT FILMMAKER

"The guerrilla nature of filming action sports, the fences hopped, the lack of permission, the constant battle with a culture...difficult, but thoroughly rewarding."

CHASING THE
ELEMENTS | *Brett Novak*

With a background working on mainstream commercials and feature films and making music videos for the likes of Kanye West, Britney Spears, Lil Wayne and Lady Gaga, Brett found himself immersed in an industry that he quickly grew to love as well as tire from. In recent years and by following his two passions of filmmaking and skating fulltime, he lives, by his own account, authentically and on his own terms.

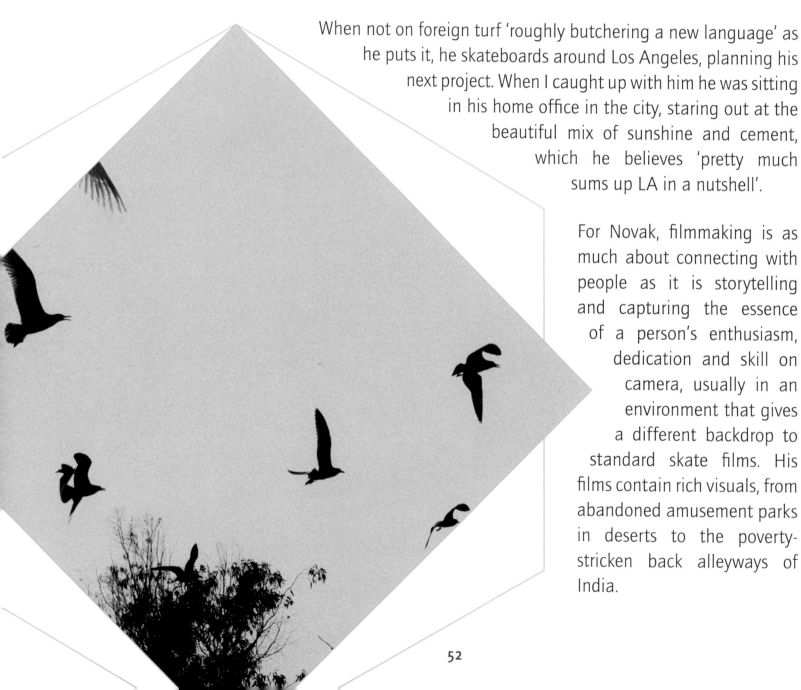

When not on foreign turf 'roughly butchering a new language' as he puts it, he skateboards around Los Angeles, planning his next project. When I caught up with him he was sitting in his home office in the city, staring out at the beautiful mix of sunshine and cement, which he believes 'pretty much sums up LA in a nutshell'.

For Novak, filmmaking is as much about connecting with people as it is storytelling and capturing the essence of a person's enthusiasm, dedication and skill on camera, usually in an environment that gives a different backdrop to standard skate films. His films contain rich visuals, from abandoned amusement parks in deserts to the poverty-stricken back alleyways of India.

You're on the hoof a lot, and this is the first time you've slept in your own bed in some time. What's been the highlight of this past year?

In a specific sense, I'm extremely proud to have just recently put out a short skate film entitled *Kyanq*, which, conceptually, has been on my mind for over a decade. Filmed in Armenia with the entirety of the post-production happening in this very room, I think the process of pulling off that film will inform my work to come for years. In a broader sense of the question, I'm extremely proud to have actually pulled off getting by doing what I love. I left my last job six years ago with no expectation that I'd make it this far working for myself, and now I couldn't imagine it any other way.

What will you be focusing on over the next few months?

Kicking out more of the conceptual pieces I have floating around my head. It's a whole other approach to my usual filmmaking and requires an entirely different planning and pre-production, but holy hell is it rewarding.

What does a typical day look like?

Wake up later than I'd like to. Work out more than I want to. Knock a skate out around the neighborhood to get in some of that California sunshine. Get home, work on projects in the office until my brain feels fully melted and end it all with zoning out to a few albums on vinyl. Throw in food somewhere in between all of that, most likely. And coffee. Definitely copious amounts of coffee.

What is it about filmmaking in the action sports environment that motivates you?

It was wholly unintentional, first falling into all of this. I had already started my obsession with film and storytelling, but then skateboarding came and entered my life. I fell in love with skating so hard that the emotion I had connected to the act of it started to spill into my documentation of it. That same feeling, that same strangely spiritual connection I have with riding a board is for sure the biggest informer of my motivation toward filming it. The most difficult part of it happens to be the most rewarding aspect as well; isn't that how it always is? The guerrilla nature of filming action sports, the fences hopped, the lack of permission, the constant battle with a culture so in-tuned with opposition in regards to what you're trying to do. Difficult, but thoroughly rewarding. People love it when it's packaged neatly in front of their screen, but it's infuriating to them when they can hear a kid practicing the same thing around their town. As George Carlin puts it: "...Not in my backyard!"

Where has been your favourite place to film to date?

It's interestingly split between two polar opposites. Spots that are so desensitized to skateboarding, LA for example, that you blend in and can get a lot done. Nobody is excited to see you. On the other side, spots that are so actively new to the sport, having literally never experienced a skateboard in person. In much of India, for example, it may be much tougher to pull off a video as the modern city exists much differently. The ground is extremely rough, if cemented at all. The people are so curious that it becomes difficult to clear space to actually skate in the first place, but these are the same people who instill a sense of humility that you otherwise may have taken for granted. It validates your own initial curiosity about the sport that you may have otherwise buried into your childhood.

"I remember standing in line at 10 years
old, waiting to get an autograph from
'Weird Al' Yankovic."

Did skateboarding play a large part in your childhood?

I grew up in the Chicago area of the Midwestern USA. A very standard lower-middle-class suburban surrounding with the big city a short train ride away. I loved nothing more than heading into downtown and skating around aimlessly with friends. The youngest of three kids, I was pretty independent once I hit the age of 14 or so, consequently around the time skateboarding entered my life. I'd constantly be gone – if not in school then usually out skating with friends and working on videos. I practically lived at my local skatepark. I remember standing in line at 10 years old, waiting to get an autograph from "Weird Al" Yankovic. Finally getting up front, receiving said autograph and then accidentally smearing it with my finger on the way out.

I had a brief stint working in retail at the age of 16 which only taught me how terrible I was at having a boss. I enjoyed working, I always have, but was politely terrible at handling the idea of having to do as somebody else ordered. This wouldn't be a thing I properly understood about myself until my twenties.

And what about using cameras as a kid?

I had been interested in filmmaking from a very young age, experimenting with an old family's VHS-C camera, attempting to make claymations. I loved working with clay and somewhere along the way started making little crude stop-motion videos. Sometime around early high school, just before I started skateboarding, a very knowledgeable friend of mine recognized my growing interest in the cinematic side of film. He spent a summer pushing films and directors onto me that he thought I'd get something from. This is what started to develop my love for directors like Tarantino, Jonze, Cunningham-artists with unique views of their own craft.

"The travel that I've made so heavily a part of my experience has given me such a rich view of human culture."

Do you think you've gained any insights by doing the work you do?

I tend to focus my efforts on highlighting the "uncool kids of skateboarding", minds that get off on expressing themselves in whatever goofy and strange ways that work best for them.

CHASING THE
ELEMENTS | *Brett Novak*

Constantly surrounding myself with solo-minded people has expanded my own views on the world and my own work. Similarly, the travel that I've made so heavily a part of my experience has given me such a rich view of human culture, far exceeding what would have been had I never left my own home state.

Who has had the most influence on you?

I like to think of myself as a fortunately decent combination between both of my folks. My mother, a very much art- and music-minded woman with a hesitant, but open-minded view on work. My dad, an insanely sarcastic self-ascribed realist with a stubborn, but very efficient, view of making a living, all while secretly having a soft heart. One of those dads you wouldn't know was proud of you until you heard it from somebody else "Oh ya! He's always talking about you!" I met somewhere in the middle, ending up with a whimsical, but smartly crafted way of making a living doing what I do. I tend to think I got my way of talking from my dad, and my view of the imagined world from my mom.

The list of people I've looked up to in my life is a sea of inspiration for me, but equally slippery and constantly evolving. I've been fortunate to pay attention to people who have stood the test of my own changing views, people who I only appreciated more as I grew older with a richer perspective of the world.

"I head up to central California to camp out under the stars...it's a wonderful, humbling reminder of how significantly insignificant I am."

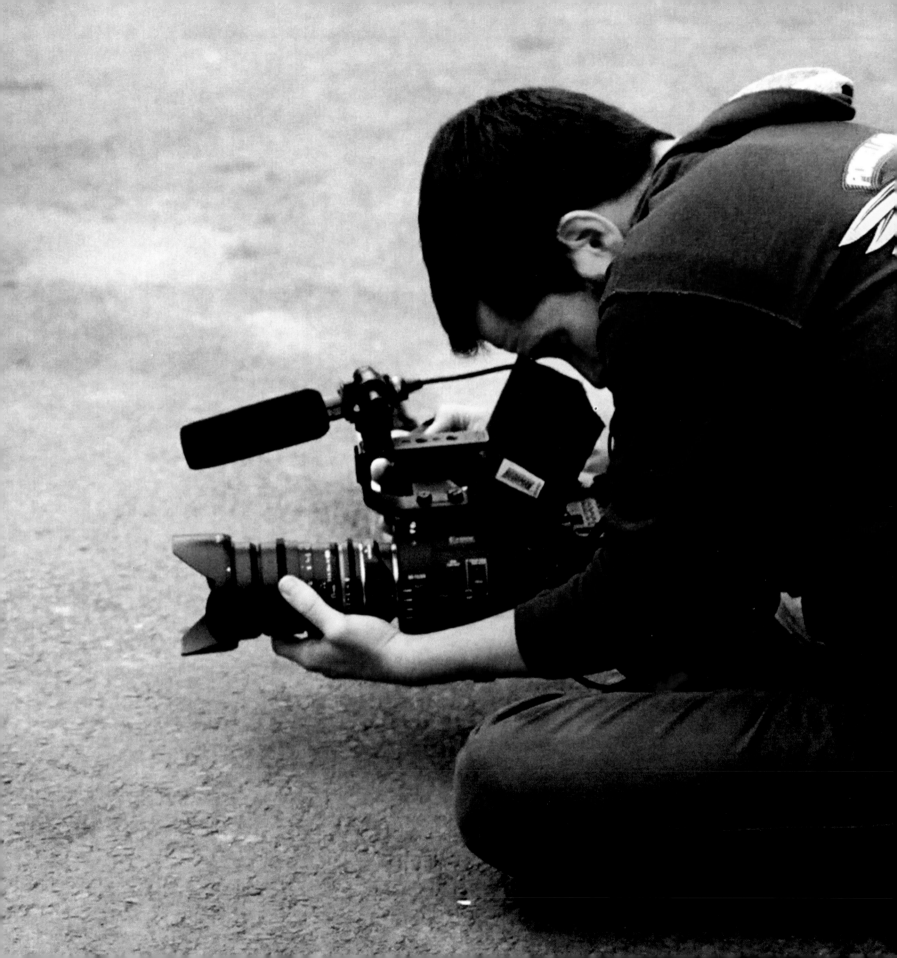

How large a part does nature play in your life?

I grew up as a city kid in love with the concrete jungle. The outside laid out my ability to skate and find myself. The older I get, the more my focus turns toward the "less impacted by humans" scenery. The feeling of being surrounded by the diversity of plantlife, weather, bodies of water —this is where my brain feels most at rest these days. Every day, filming in these environments is an exercise in recognizing the present while avoiding tainting it with the existence of the camera. Every year I head up to central California to camp out under the stars, and it always acts as a reset button for me. No matter what I've done or where I've been that year, it's a wonderful, humbling reminder of how significantly insignificant I am.

Where in the world are you planning to visit next?

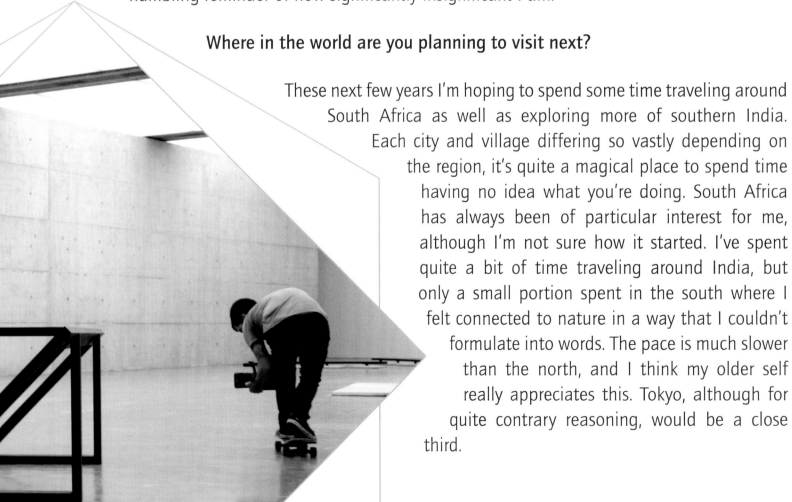

These next few years I'm hoping to spend some time traveling around South Africa as well as exploring more of southern India. Each city and village differing so vastly depending on the region, it's quite a magical place to spend time having no idea what you're doing. South Africa has always been of particular interest for me, although I'm not sure how it started. I've spent quite a bit of time traveling around India, but only a small portion spent in the south where I felt connected to nature in a way that I couldn't formulate into words. The pace is much slower than the north, and I think my older self really appreciates this. Tokyo, although for quite contrary reasoning, would be a close third.

Which action sports do you do yourself?

Skateboarding would probably be my only consistent sport, although even labelling it that is a big ol' can of worms. I can appreciate what people get out of almost any sport. I just happen to find my happiness easiest blasting down the road on a board with a pair of headphones.

Living in California, I'd like to get more and more into surfing. It's hard to express how much skateboarding and surfing don't go together if you didn't grow up in a surf environment. People tend to think that if you skate you almost automatically have the same kind of connection with other board sports, but it's honestly rarely the case. That being said, the few times I have tried surfing I quickly fell in love just as I had with skateboarding some 15 years earlier.

What have you learned about yourself which you wish you'd known sooner?

Resentment grows from within, and thus 99% of the time whatever bad thing the world is doing to you, it's most likely just your own internal instilling of a feeling. Every job that I ever held that I grew to hate really stemmed out of my own decision not to fully commit to focusing on what I wanted to be doing, rather than what I thought I was supposed to be doing. When you've burned yourself out of a situation, it's often difficult to see that the situation is just as awesome as when you started, just you have changed.

Which aspirations currently remain out of your grasp?

I quite honestly feel like I'm already there. Making a living, no matter how modest, expressing myself as genuinely as I can, all while connecting with people on a level deeper than the surface. When people tell me that they literally shed a tear at the end of a skate video of mine, I know that the emotion has translated. That skateboarding, or anything we do as humans, digs quite a bit deeper than just a day-to-day activity.

"Most people wish you no harm, and thus it's important to treat the world as such."

Which trait do you find most challenging in others?

Bigotry, particularly when it comes to foreign cultural interaction. The fear of the outside world, as in outside of your own culture, is extremely real for people, and the only way they know how to deal with it is to distrust it. Even at the extreme end of intense political, religious or moral disagreement, people are overwhelmingly well-meaning. Most people wish you no harm, and thus it's important to treat the world as such.

What do you dislike about yourself?

That's fortunately kind of a tough one for me. I tend to do a lot of self-reflection to the point that I try not to keep up any traits that are definitely in need of some evaluation. I'd say my whimsical side in regards to how I look at money and my contempt for the need of it can often get in the way of staying comfortable, but ironically it's often this approach that tends to do me the best. As long as you're comfortable with the inevitable occasional struggle, the long-term game tends to be in your favor.

What's your biggest strength?

Patience. Patience is the key to keeping yourself open to a better you.

What are your thoughts on why action sports are so big?

The common answer tends to revolve around the lack of rules, team, coaches, etc., but I think the problem comes with comparing them to "regular" sports in the first place. Skateboarding,

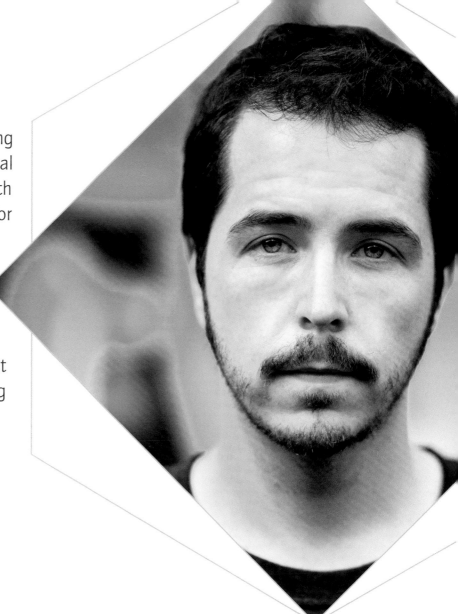

in my opinion, for example, is closer to playing the piano than throwing a football. The goal of skating is never to get to some point with it, to master everything, to get picked up for competition. Like learning an instrument, it is all about self-improvement with a never-ending quest to compete against yourself. You will always have something to learn from it and always have the power to contribute to it. You are your own most important audience, teacher and ever-learning student.

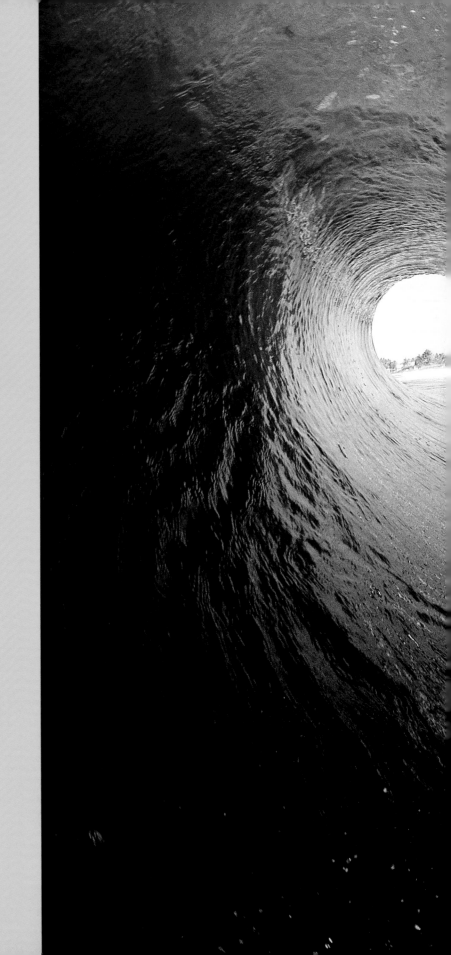

INTERVIEW

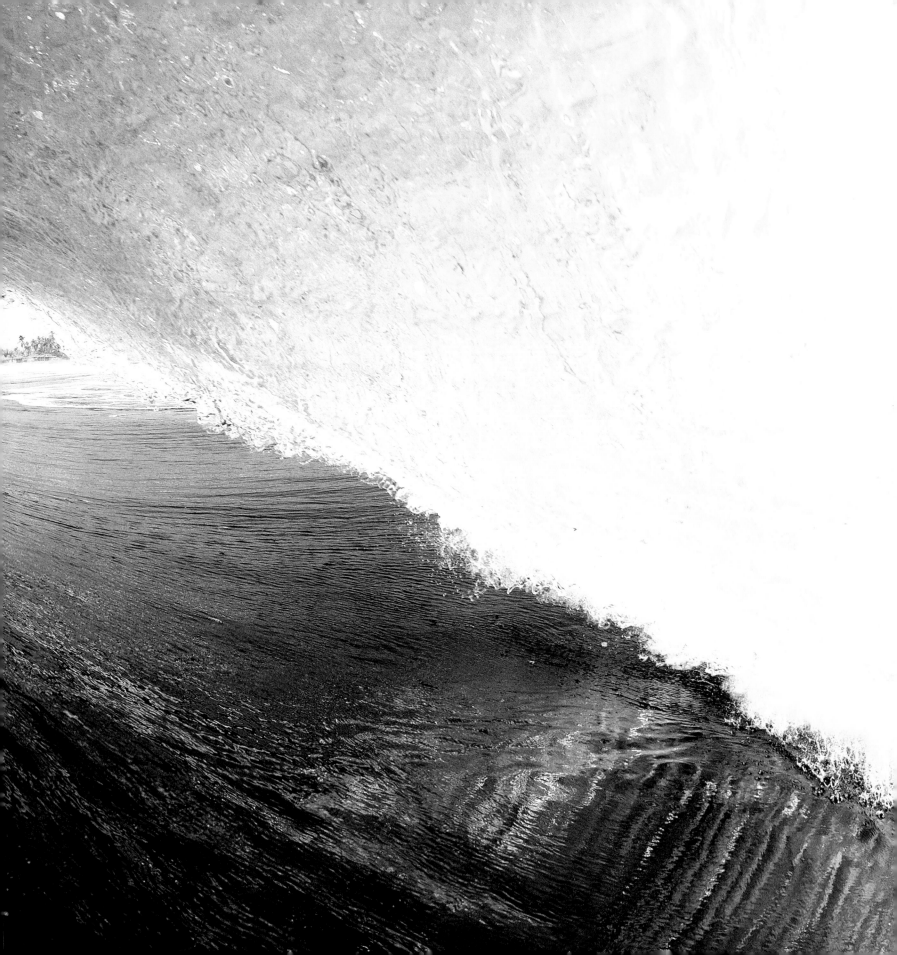

LUCI ROMBERG

PRO STUNTWOMAN AND FREERUNNER

"I want to inspire people to chase their dreams, to never give up and to do what they love."

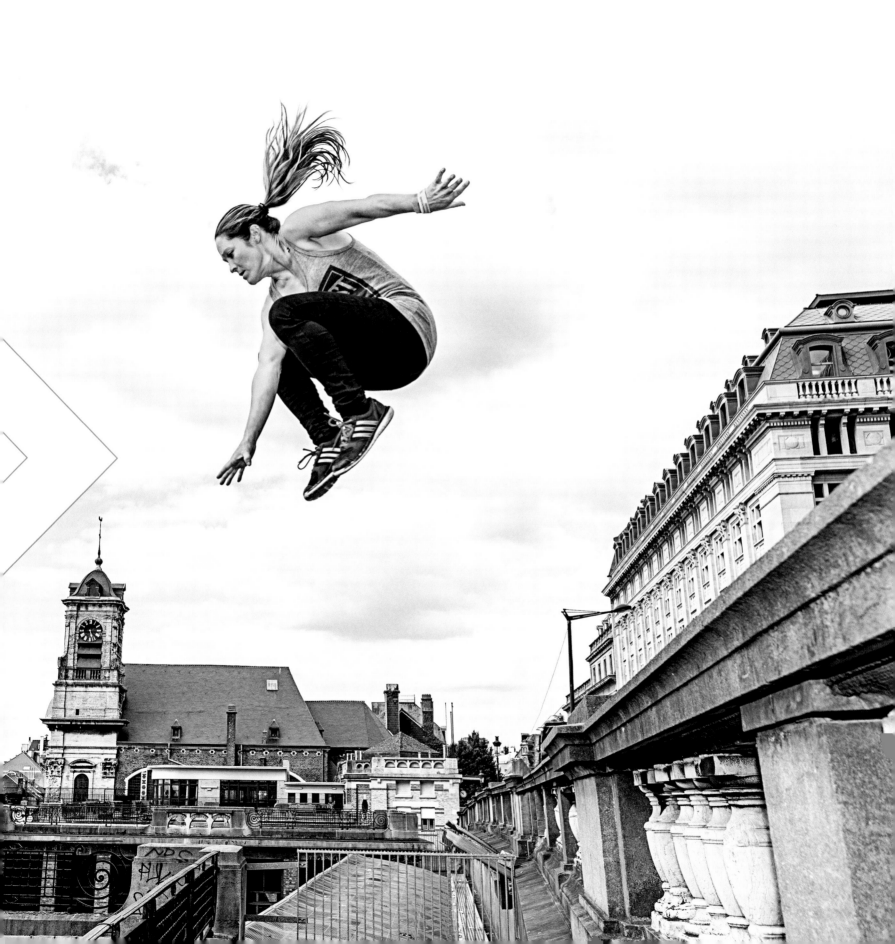

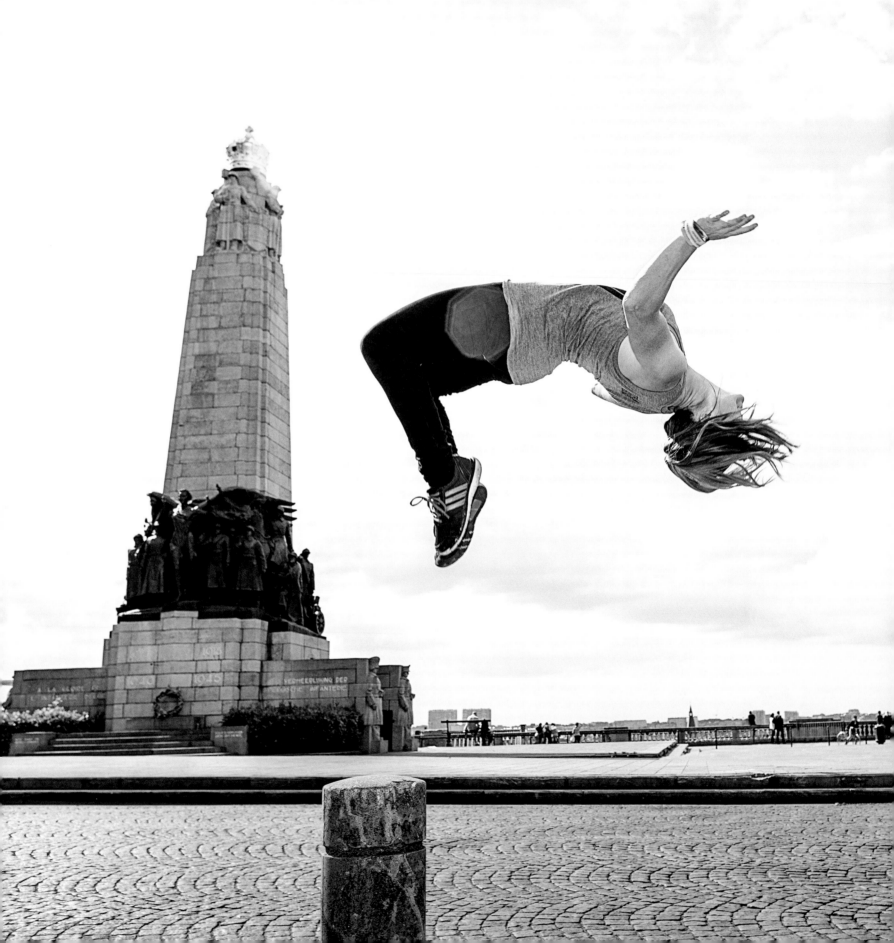

Luci's a professional stuntwoman and freerunner with Tempest Freerunning based in Los Angeles. Tempest is an 11-person strong crew who come from various types of athletic disciplines. Some of the members are the 'go-to' people when Hollywood film directors are looking for stunt men and women to tackle the gnarlier physical aspects of their latest film.

She's worked on TV shows like House, 24, The Mentalist, a ton of blockbuster movies and bread-and-butter commercials for household brands like Mazda, McDonald's and Mountain Dew.

Luci is currently working on the fifth and latest installment in the popular Bourne spy thriller franchise. When I catch up with her in at the Monte Carlo Resort in Las Vegas, she's on the 31st floor and gazing out at the Las Vegas strip.

What are you most proud about from last year?

Being Melissa McCarthy's stunt double for Ghostbusters and The Boss as well as winning my 11th Red Bull Art of Motion award.

When you cast your mind forward to, say, 2018, what can you see?

I'm seeing my freerunning company, Tempest continue to grow! I'm excited to expand our the USA and sponsor athletes from other excited to see my stunt career grow and what I love!

Talk us through a typical day for you...

No days are the same for me. When I'm on a stunt job we are always doing something different, whether it be falling down a flight of stairs, hanging from a helicopter or fighting off five bad guys. When I'm not working, I'm focusing on getting the next job by training–this usually takes place at Tempest Freerunning Academy in L.A.–and eating healthily and sending out headshots, a long list of tasks.

"There is no right or wrong way in freerunning. There is a safe and an unsafe way, but no wrong way."

What is it about freerunning that motivates you?

The freedom of it. There is no right or wrong way in freerunning. There is a safe and an unsafe way, but no wrong way. However your body moves is what goes. I love the mental and physical challenges it brings, and I'm never good enough, so I'm always striving to learn more and get to the next level. I love training in Tempest South Bay because it's an incredible facility, and there are always people popping in and out who you can train with. There is never a dull moment and always something new and exciting to perfect.

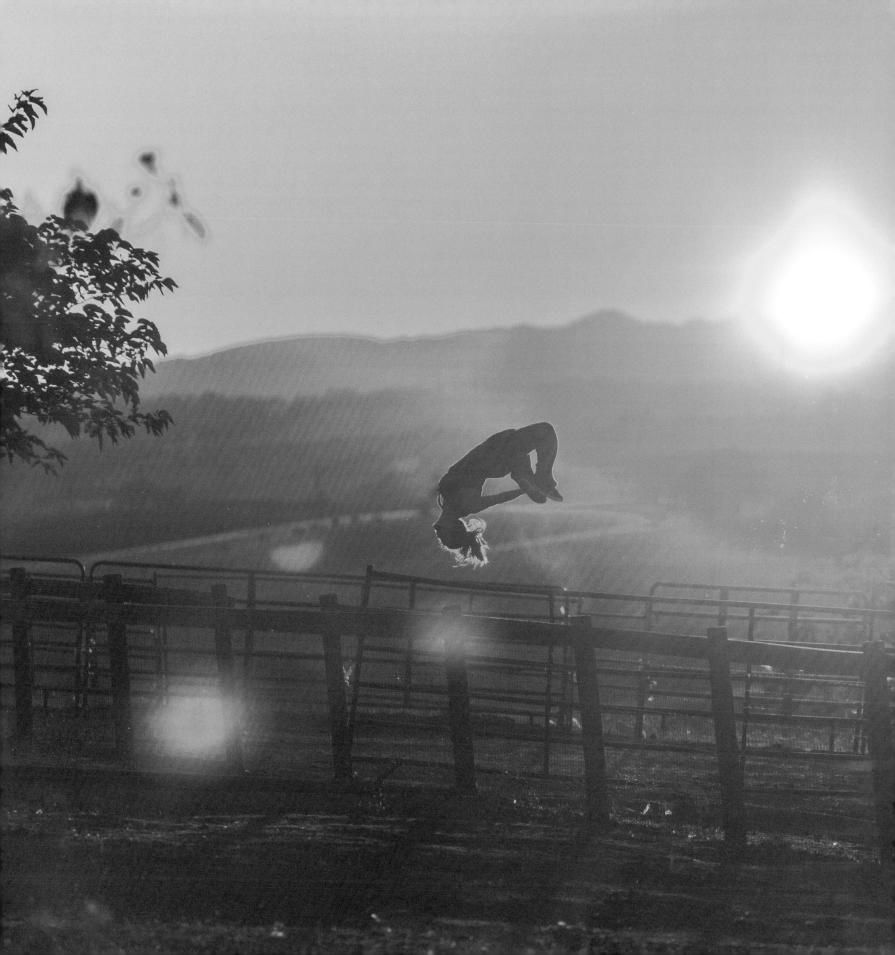

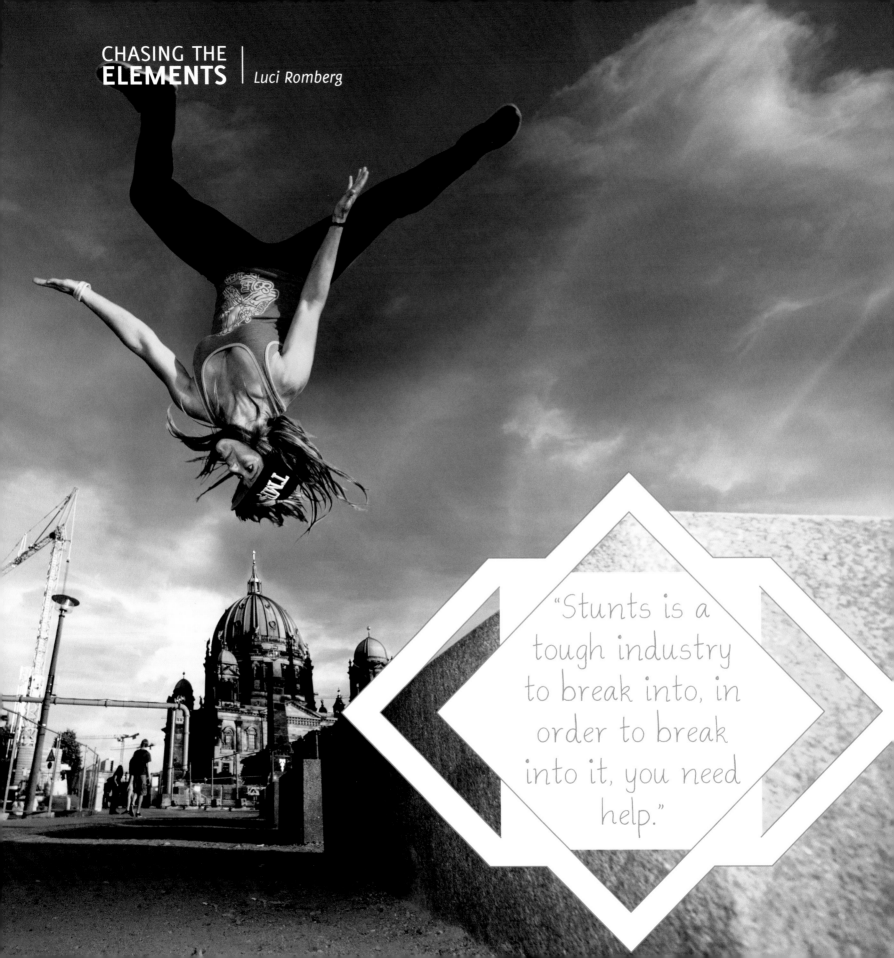

CHASING THE ELEMENTS | *Luci Romberg*

"Stunts is a tough industry to break into, in order to break into it, you need help."

What are the biggest challenges in your line of work?

The mental challenges. It is a scary sport ,and even if you are 100% physically capable of something your mind often gets in the way, so it is a great feeling to overcome that fear.

If doing your job wasn't an option, what do you think we'd find you doing instead?

I'd probably have been a personal trainer, I got my college degree in Kinesiology and I love movement and helping people so that's probably the direction I would have gone.

Tell me about where you grew up and how you were raised?

My parents are amazing!! I grew up on a small farm in Aurora, Colorado. My mom loves horses and animals so there was always a lot going on in my house. Both my parents earned collegiate tennis scholarships, so sports were an instrumental part of my upbringing, sports have done more for me than anything, growing up I played soccer, gymnastics, tennis, softball, volleyball, and diving and I went on to play soccer and gymnastics in college. My parents let me try every sport I ever wanted to, I'm so fortunate to have such awesome and supportive parents, they always taught me the value of hard work, of never giving up, and told me to do what I love and I'm so glad I listened to them.

You also have an impressive list of movie stunt work to your name. How have you built your reputation in the industry?

Thanks! The biggest films I've worked on are *Ghostbusters*, the *fourth Transformers*, *Spy*, *Indiana Jones*, the fifth *Bourne*, *Divergent*, *True Detective*, and quite a few others. Stunts is a tough industry to break into; in order to break into it, you need help. Because of that, I'm grateful to so many stunt people who've helped, guided, and given me great advice along the way. It amazes me how much I learn on every movie! Every show and every stunt coordinator is different, so it's important to have good set etiquette and to be ready for anything. It's also important to be in the best physical shape possible.

How did you get into the movie business?

I was a national champion gymnast in college, and my good friend, Natascha Hopkins, who was on the gymnastics team with me but is a few years older, was out in Los Angeles doing stunt work and acting. She convinced me to move to L.A. once I graduated and give stunts a try. It was a really scary thing to do, leave my friends and family behind and move to a huge city where I knew no one, to pursue this dream I had no idea how to realize. But through hard work, perseverance, dedication, and help from others, I figured it out.

Where in the world would you most like to get lost?

Getting lost in Santorini, Greece, is the best. You can stay on the rooftops for such a long time, and a lot of the buildings are connected, and sometimes you get to jump

from one rooftop, to another. When I was there, we got lost exploring for hours. I'm going to Uganda, South Africa, and Madagascar in April with my mom, sister, and good friend from high school. I'm really excited! Next year I hope to go to Antarctica. One of my life goals is to go to all seven continents, and Antarctica is the last one on my list. It looks absolutely breathtaking.

Tell me about one of your favourite childhood memories.

So many of my memories revolve around movement. We had a game called "Troll" when we were little that we would play all the time on the stairs. It's a little hard to explain, but the second story landing in my house was open, so we could walk all the way around the stairs. My dad was the "troll' and he would have to stay on the stairs and would try to tag my brother, sister, and me as we would run and jump and try to avoid being tagged. We had so much fun playing that game. I also have a lot of fond memories being with my mom in the barn and playing with the numerous animals around the farm. We had horses, goats, ferrets, cats, dogs, rabbits, turtles, chinchillas. It's probably why I love animals so much as an adult.

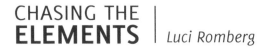
What have you learned about yourself which you that you'd known sooner?

It took a really long time, but I finally learned that I am beautiful just the way I am.

What's your ultimate dream?

I guess everyone in some way wants to leave a mark. I want to leave a positive imprint on the sport I love so deeply and the career I love so much. I want to inspire people to chase their dreams, to never give up, and to do what they love.

> "To watch someone do something that seems impossible is so awe-inspiring, and inspiration is such a powerful emotion."

Why do you think actions sports have such a huge following?

Watching extreme sports inspires people. They test the limits and go beyond what people know is possible, so to watch someone do something that seems impossible is so awe-inspiring, and inspiration is such a powerful emotion. I have a good friend named Larry Rippenkroeger, who is a pioneer and was the best jet skier in the world for a long time. He's told me all about jet skiing, and it sounds really fun.

Which world issue resonates with you the most?

The lack of acceptance that still exists in the world makes me sad. I wish people could love one other and live and let live.

How big a part does nature play in your life?

I love nature, of course. I love animals. I'm a vegetarian partly because I love animals so much. I love climbing trees, hiking and pretty much anything outdoorsy. It's such a peaceful place to be, and you can relax and get away from the hustle and bustle of everyday life. I grew up in the country, and we were outside playing and working all the time; having the warm sun beat down on you while working up a sweat is a great feeling. I went to Sicily, Italy, with my mom and sister last year. We climbed the Mount Etna volcano. While all the other tourists took the cable car up, we hiked it, and I feel we got such a better appreciation for its ruggedness and beauty. The landscape made you feel like you were on another planet. It was truly incredible.

SOCIAL
WEB WWW.LUCIROMBERG.COM
TWITTER & INSTAGRAM @LUCIROMBERG

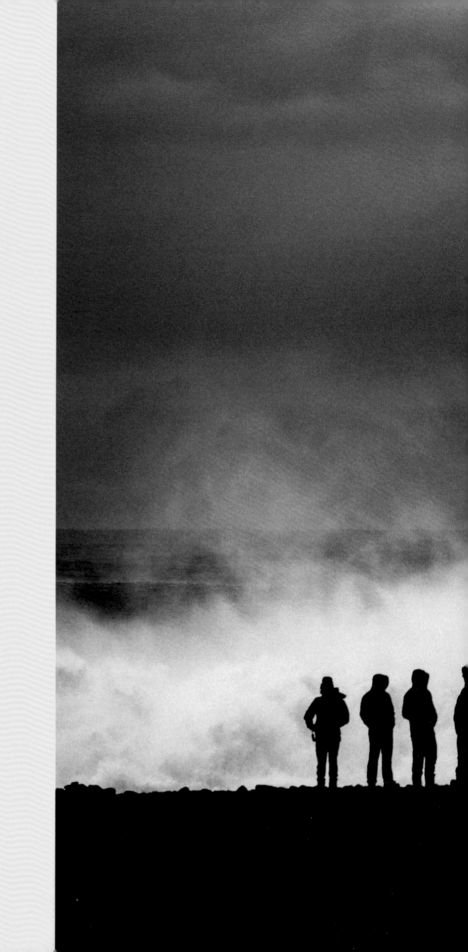

REFLECTION

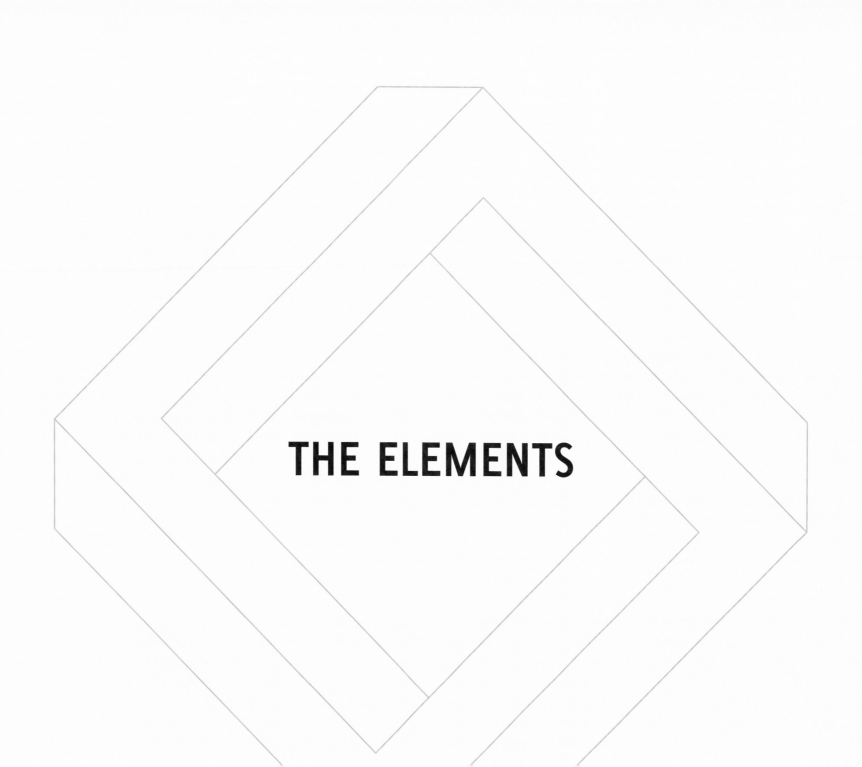

THE ELEMENTS

Modern life may encourage a tendency to view the natural world as just another consumable commodity. Yet, as the perception of the action sports athlete has changed from delinquent to successful entrepreneur, so, too, have positive associations emerged between sport and the preservation of the environment upon which the athlete relies.

To onlookers, mountains covered in snow, bike trails through a forest, the confluence of river rapids, cavernous deep waters or challenging rock ascents, act as playgrounds or battlefields for action sports enthusiasts. An environment in which to test the human capacity for physical achievement. When we watch these activities, we may only think how incredible the feats happening before us seem and ponder the amount of inherent risk involved. We're thrilled, watch on in awe at the spectacle taking place in front of us, yet in so doing, we can become blind to the magnificence of the landscape.

In being out in the elements, they're establishing cherished and faithful bonds with the great outdoor.

But this is changing. Athletes, pro and amateur alike, as well as their on-looking well-wishers are voicing something that they've noticed happening to them. In being out in the elements, they're establishing cherished and faithful bonds with the great outdoors and realising that, without nature, the opportunity to showcase their physical robustness, action sports and life as they know it wouldn't exist.

Over time, societies have systematically insulated themselves from nature in pursuit of a more secure and comfortable existence; we've restricted ourselves with hierarchy,

borders, rules and our own fear. In so doing we've separated ourselves from certain realities, namely what's happening to our environment and how much of this is due to our abuse of it? With vast quantities of plastics in our oceans, glaciers and polar ice caps melting at a worrying rate, deforestation, the loss of biodiversity, we're experiencing a moment in time never previously recorded in human history. The effects of these changes are becoming more visible, more dramatic and in time will threaten the continuation of our using the elements so freely. From this global realisation, environmentally sustainable practices emerge, with new conservation efforts appearing daily across the world.

When we experience wonder, authenticity and elation whilst embracing an outdoor adventure, we feel connected to the entirety of the natural world. More and more pro athletes are recognising that in their 'superstardom' comes the opportunity—and responsibility—to raise awareness of these environmental issues. Through their celebrity, they can play an important part towards global responsibility for conservation of the environment. Our well-beingand our futures are unarguably entwined with nature's health and existence.

Our well-being and our futures are unarguably entwined with nature's health and existence.

INTERVIEW

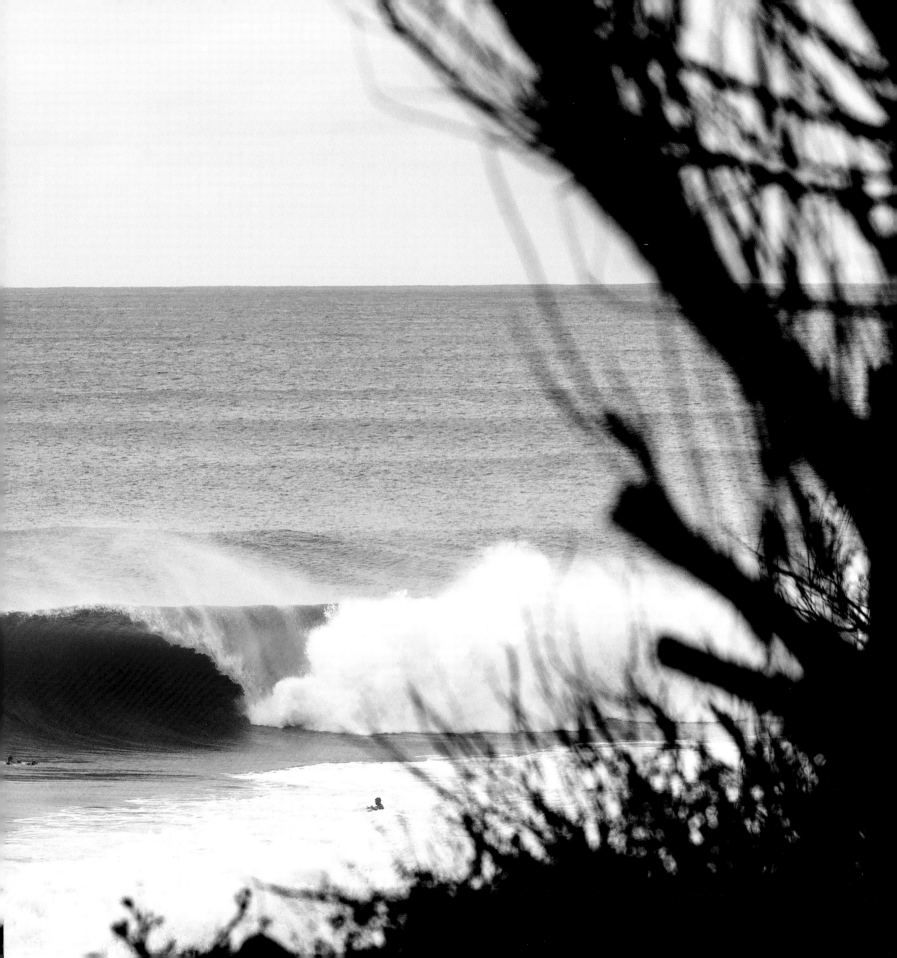

CHAD KERLEY

PRO BMX RIDER

"Nature is inevitable in anything action sports they all involve being out in it."

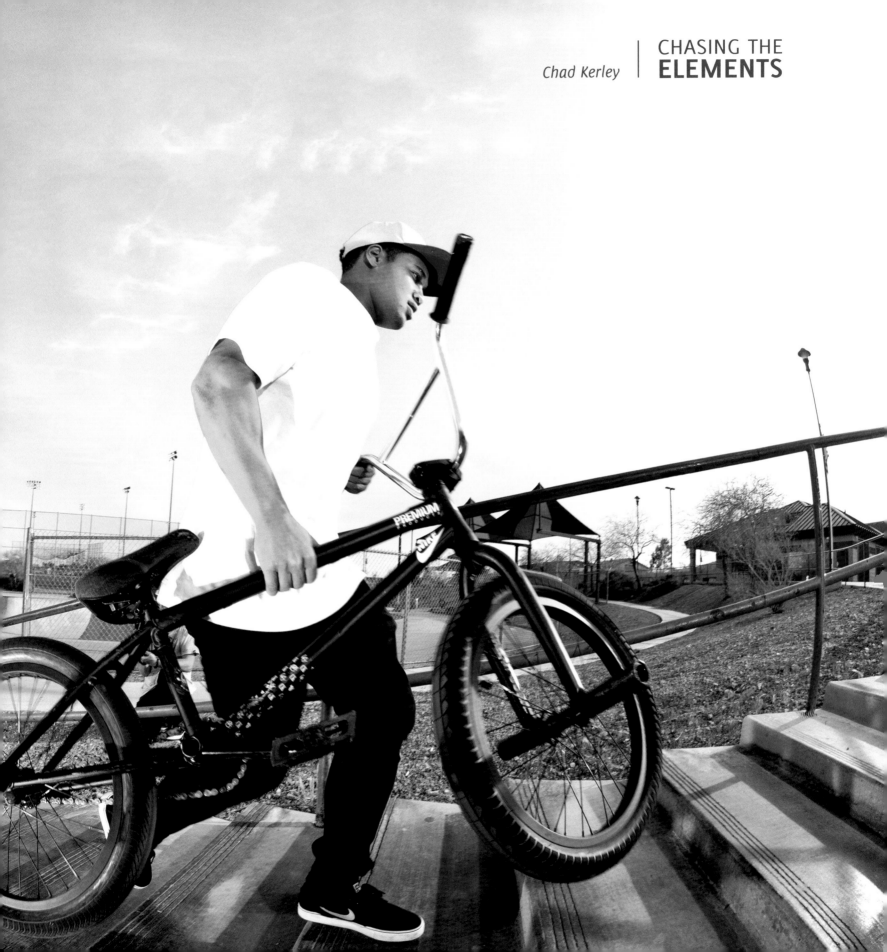

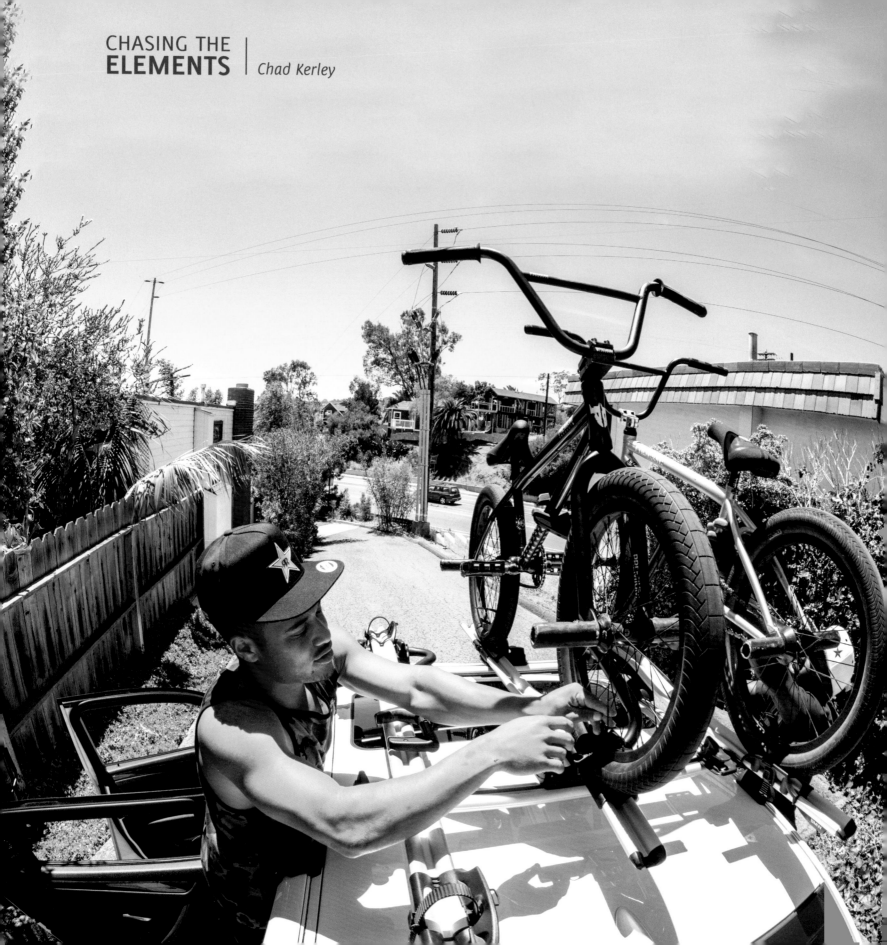

Urbanite American Chad Kerley started BMX racing at age four and was noticed by Premium BMX at age 15 whilst riding the parks and streets of San Diego, California. His professional career was kick-started by their sponsorship, and Chad now has a whole host of brand sponsors, allowing him to do what he loves best: ride all day, every day, then ride again some more.

In the past five years, he's racked up a seriously impressive wall of trophies, including gold medals in the Asia X Games, Mongoose Jam, Texas Toast, has been named as the BMX Plus Freestyler of the Year, Vital BMX Rider of the Year, Nora Cup People's Choice Rider of the Year, Ride UK BMX Worldwide Rider of the Year, Freedom BMX Global Rider of the Year, and all of this whilst working with Premium for parts and Haro for his frame to create his own custom bike setup.

He's at the forefront of BMX innovation, putting his expertise and experience into bike design: shortening the rear of his new bike, changing up the grips and putting new high-end aftermarket parts through their paces so that, as he says, "it feels the way I want it to."

During some downtime at his home in San Diego, Chad and I talked BMX whilst sitting on the couch with the TV on in the background. He points out the cool view of the city from his living room as he gestures past a stack of BMX magazines and PlayStation controllers.

Your rise in the industry seems meteoric to outsiders looking in; what would you say is your biggest achievement from last year?

I'm really proud about my "Cinema" video part dropping last year. I worked hard on it for over two years and held on to my best clips from the trips we had. I rode a lot of spots in L.A. that I had been wanting to go to, and I got the cover of *RIDEbmx* magazine while working on the video.

Is riding on film something you'd like to do more of in the coming years?

Yeah, I'm looking forward to dropping more videos and progressing on my bike while having fun. I have been working on a video with a filmmaker named John Hicks, who I don't get to meet up with often, and I'm really looking forward to finishing it up within the next year. He's got a dope style to the way he films and edits, so the vibe is going to be like no other video I've ever had. I can't wait!

What does a typical day look like for you?

Usually I wake up and think about where I'm going to ride. I have this conversation with myself pretty much every morning while lying in bed. I hit up one of the homies and see if they're down to ride, and we usually meet

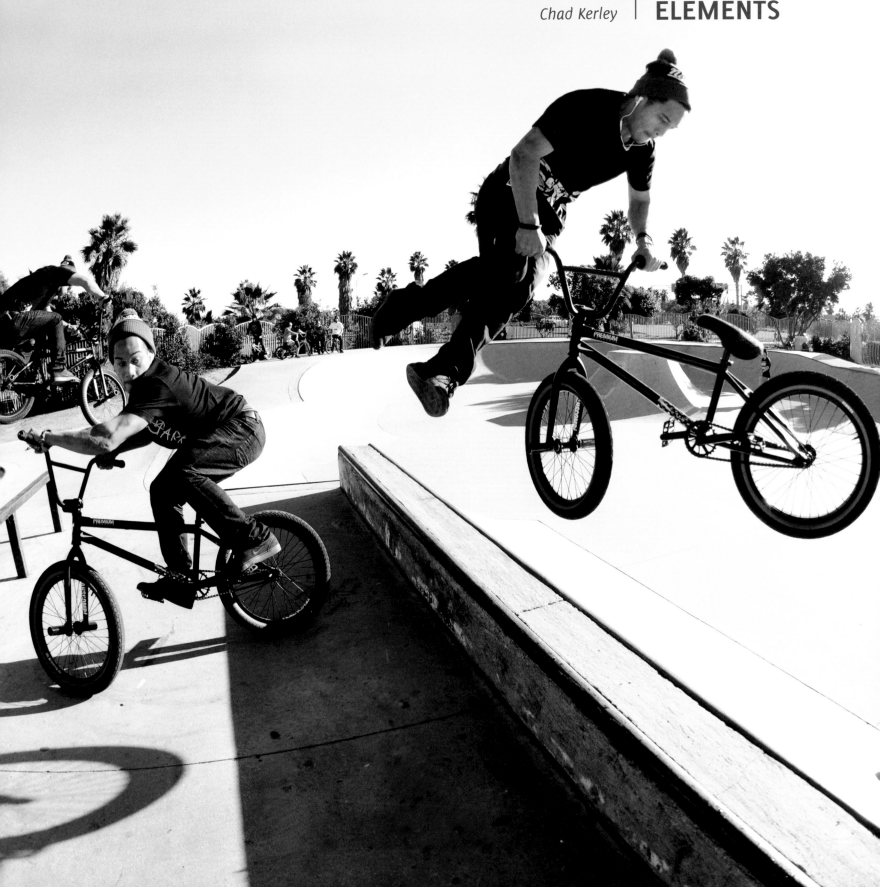

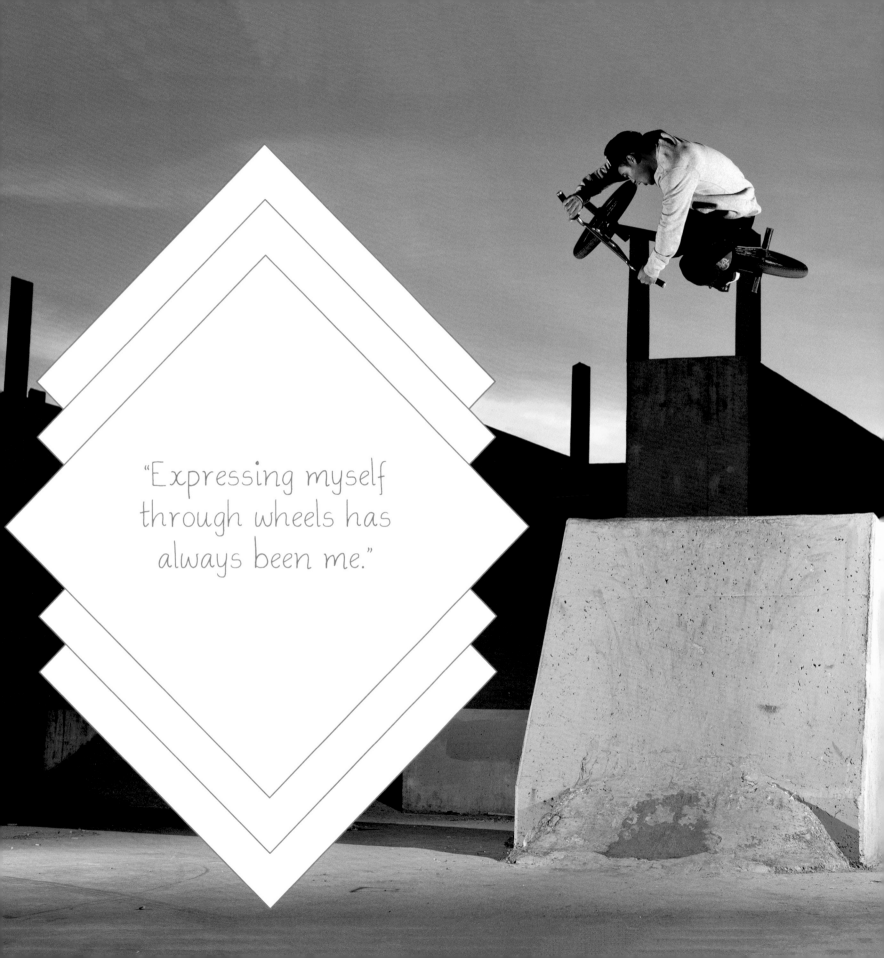

"Expressing myself
through wheels has
always been me."

up and shred. If we hit up a park, we usually ride for a few hours and chill the rest of the day. But if we go out and ride the streets, we're usually out all day. Spots are hit or miss, so we hit up multiple spots throughout the day all over San Diego. After a long day of riding, I get home, shower, stretch, and eat.

Why BMX, and what motivates you?

I have so much fun doing it that nothing else gives me the same feeling. Just being on my bike keeps me sane; it's all I know. The passion I have for riding keeps me motivated to keep learning new tricks and just staying on my game.

It's not the easiest of action sports to pick up. What do you find the most challenging?

No matter how fun BMX is, it definitely takes a toll on the body. Lately, I've found that keeping my body, specifically my lower back, in good condition has been tough. I do as much as I can as far as stretching and using a foam roller to keep me right. I realized that I needed to do a little more, so I've been working out a bit to keep my back strong. It's been helping a lot, but it has definitely been difficult figuring out the balance to keeping my body good to ride as I've been getting older.

So if a different set of opportunities had come your way, what do you think you may be doing instead?

I'd definitely still be into action sports. It's just who I am; expressing myself through wheels has always been me. Whether it be riding dirt bikes, skateboards, or even racing go-karts, anything on wheels keeps me hyped.

93

Where is your favourite place to ride and why?

My favorite go-to place to ride is Ocean Beach skatepark in San Diego. It's really close to my house, which is convenient, and a lot of my friends go there. If I don't feel like riding street and want to get a session in, that's where I'm usually at.

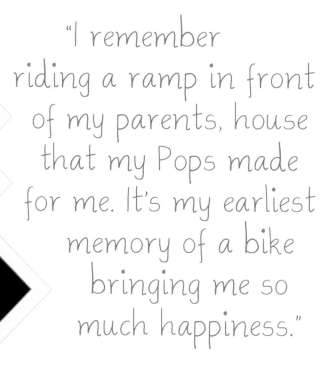

"I remember riding a ramp in front of my parents, house that my Pops made for me. It's my earliest memory of a bike bringing me so much happiness."

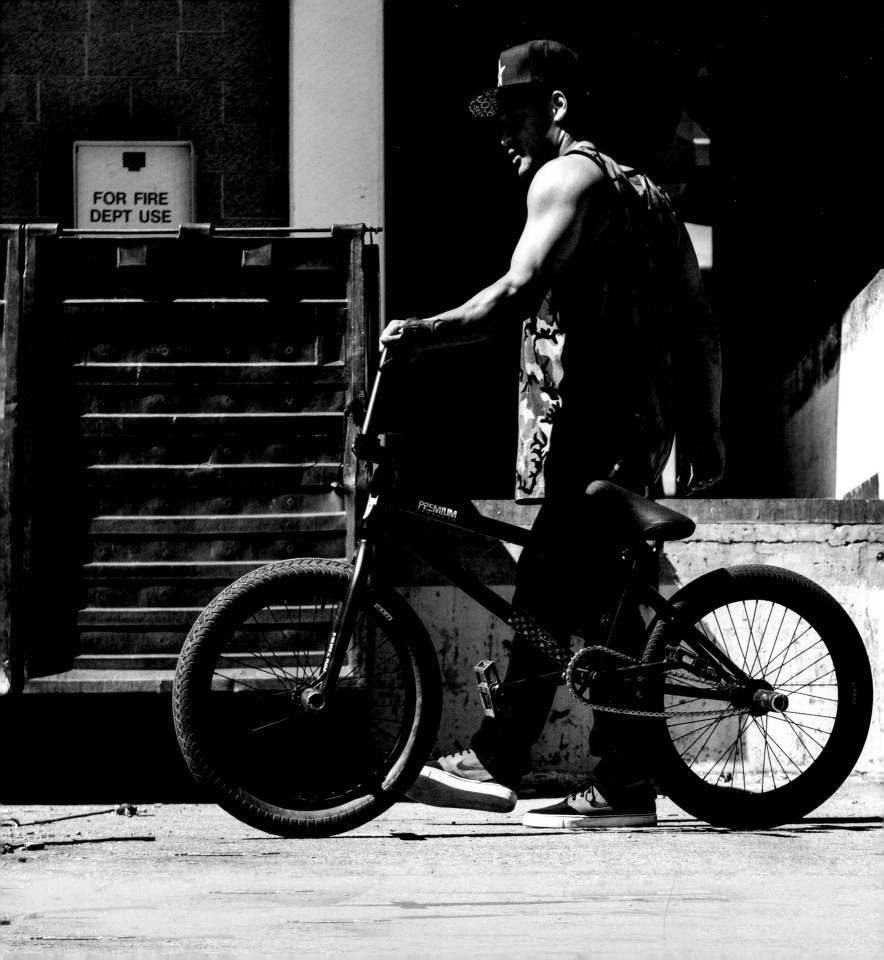

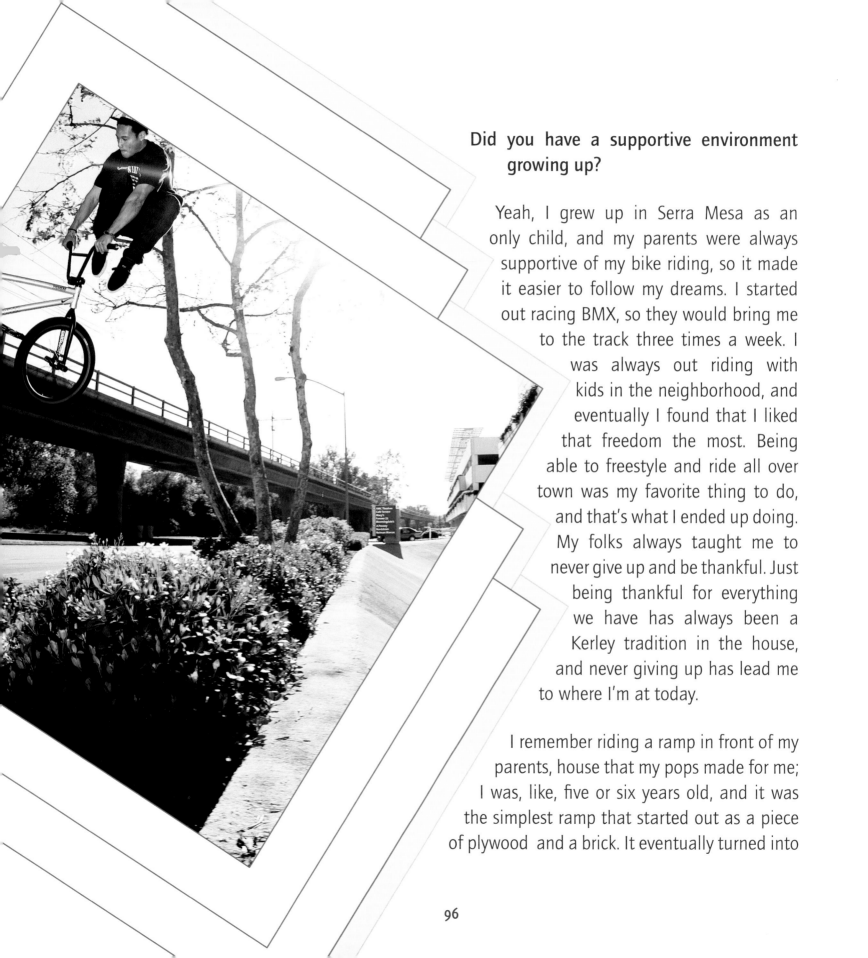

Did you have a supportive environment growing up?

Yeah, I grew up in Serra Mesa as an only child, and my parents were always supportive of my bike riding, so it made it easier to follow my dreams. I started out racing BMX, so they would bring me to the track three times a week. I was always out riding with kids in the neighborhood, and eventually I found that I liked that freedom the most. Being able to freestyle and ride all over town was my favorite thing to do, and that's what I ended up doing. My folks always taught me to never give up and be thankful. Just being thankful for everything we have has always been a Kerley tradition in the house, and never giving up has lead me to where I'm at today.

I remember riding a ramp in front of my parents, house that my pops made for me; I was, like, five or six years old, and it was the simplest ramp that started out as a piece of plywood and a brick. It eventually turned into

96

two 2 x 4 legs with plywood. I would come pedaling as fast as I could from down the block and blast it. Kids from around the neighborhood would watch. I'd even jump over them if they were willing to lay under it. It's my earliest memory of a bike bringing me so much happiness.

Which city would you like to travel to but haven't yet, and why that location in particular?

Well, living in San Diego where the weather is so nice makes riding amazing. I love being in the sun; it gives me energy. But I'd really like to go to Dubai; the spots look amazing, and the architecture looks crazy and futuristic. I've seen videos of the place, and it definitely had me wanting to go. One day! England would be fun to get lost in. I've been once before to Dagenham for a contest but didn't get to ride much street. It'd be fun to get lost in London somewhere, especially since everyone speaks English so I wouldn't be too worried.

"Winning was seriously a dream come true. The X Games was always a childhood staple in my life."

Tell me about winning the gold at the X Games.

It was pretty surreal. I had all my friends and family there since they were close by in San Diego, so I felt at home and comfortable. I was hyped to be riding with all my favorite riders and was in good energy. It just kind of happened. I was having fun and tried to get on a roll. I couldn't believe I was sitting in first during the finals. Winning was seriously a dream come true. The X Games was always a childhood staple in my life, so it was crazy!

What has riding taught you about yourself?

I learned that stretching is a huge part of being any type of athlete. I had a long race career before riding freestyle and never stretched. My back got really bad on me right before the X Games in 2013 that I was surprised I won, actually. I remember having the medics tape me up so I could ride, and I was sitting in ice buckets all night. I never stretched my back out, or rolled it out, or got massages. I just rode and never did anything extra. If I would've known how important it was sooner, I would have been stretching many years before that happened. But, I was just being a kid not knowing the consequences, and it has caught up to me. Now I know!

Why do you think people love action sports?

I think the fact that it's so freestyle; it's not traditional like other sports with teammates. It's all about how creative one person can be, so it's cool for people to see everyone's interpretation of the sport. Especially seeing what we do on relatable street obstacles such as stairs, rails, and ledges that they use every day for normal purposes can really draw people in to what we do. Motorcross has always been something I've wanted to do. I grew up watching it, and I had a few dirt bikes growing up, but I didn't love it like BMX. It was pretty expensive as well, but it'd be fun to get a new one and start riding again.

Nature plays a huge part in action sports; tell me about your relationship with nature.

Yeah, I'm always outside when I'm riding. I grew up riding dirt and was riding in canyons. Nature is inevitable in anything action sports; they all involve being out in it. Anytime I've rode dirt jumps/trails, it's given me this feeling I get that instantly brings me back to being a kid and why I love riding so much. Flowing through jumps and going around berms is so fun.

Tell me about your current bike; how have you modified it to your chosen spec?

It's pretty normal, nothing crazy. I have no brakes like most BMX bikes do nowadays. I ride with plastic pegs instead of the traditional metal ones to help with grinds. And I don't ride much tire pressure when riding street, so I have a little bit of cushion when I land.

What does success look like to you?

Just being able to ride my bike every day for a living is an achievement in itself. I'd like to just continue being as successful as I can be in my career and travel with my good friends for as long as I can.

SOCIAL

TWITTER @CHADKERLEY

INTERVIEW

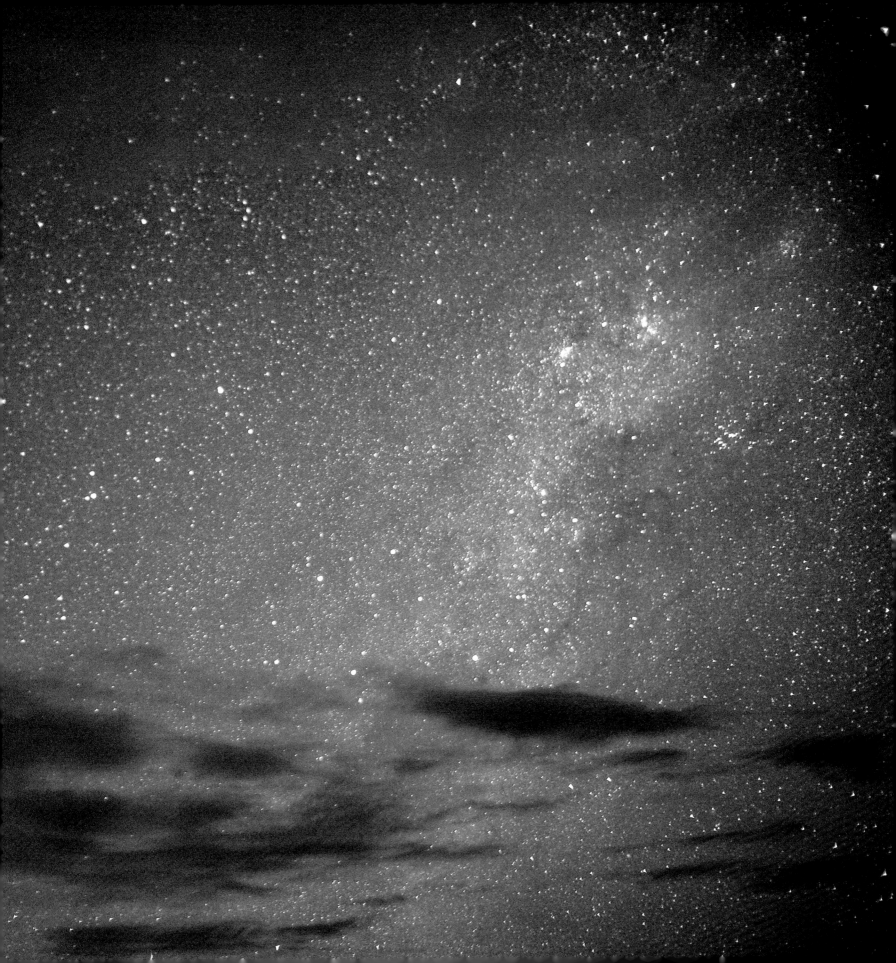

ALEX RADEMAKER

PRO SKATEBOARDER

"Skateboarding is malleable...there are intrinsic nuggets to be found. I enjoy mining to find them."

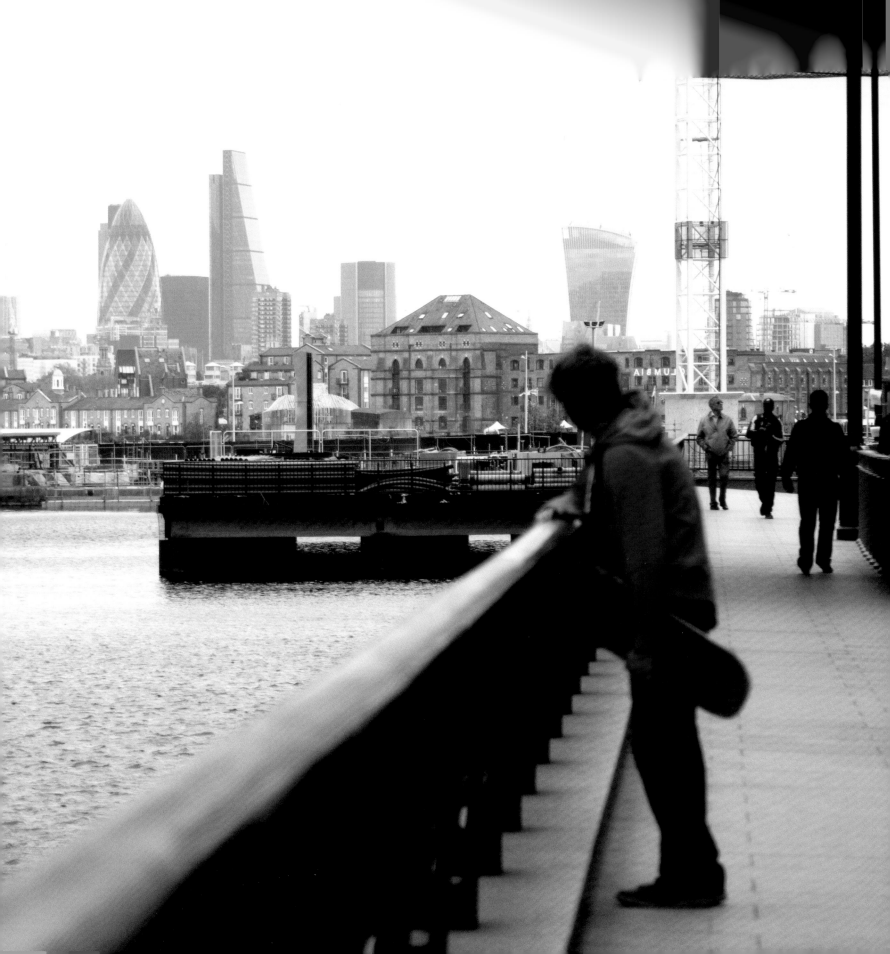

'Incredibly talented and humble with a truly deep connection with skating, he also has the biggest heart'. This is how filmmaker Brett Novak describes his friend, pro skateboarder Alex Rademaker. In chatting to Alex, it's easy to see that he fits his friend's description and that the recognition he's receiving for his talent is well deserved. He's on brand radars because his freestyle skating isn't quite the norm. He's creating his own tricks and evidently has his own style.

But what sets him apart from the rest isn't solely his ability, but also his unapologetic way of simply being himself. Talking with him is a great reminder of how being a pro skater doesn't have to fit some kind of industry mould, and by his own admission he doesn't 'think about the skate industry much'. He's an unassuming, regular, yet deeply thoughtful young guy from Geneva, Switzerland, who eats, sleeps and breathes skateboarding.

Being on the brink of a career set to skyrocket, I'm curious to know what he thinks of the world emerging before him and ask whether he's comfortable with what is appearing on his horizon.

Where are you right now?

I'm in my room right now, sitting at my desk. I'm in quite an empty room with a bed and cupboard behind me. I've got a little drying rack brimming with wet clothes at the moment. The walls are empty apart from a small wall planner on the wall next to my desk with notes of what I need to do, and since it's night-time, I can

see light coming through the curtains from the streetlights and the passing headlights of cars. I'm just hanging out!

You've been filming with one of the other fellas I've interviewed in this book, the filmmaker Brett Novak. Tell me about that.

I'm quite proud of the skate project I did with Brett Novak in Armenia called *Kyanq: A Short Skate Film*. The expression behind it is something so deeply precious to me. The video is less strictly about skateboarding, but rather more about exploring death, how it can happen at any instant and what that means. As sad and blunt as it is, anyone can die at any random point, which is awful. To me the video serves as a stark reminder to actualize my ideas as soon as possible, because that's what I have fun doing; it's what makes me happy.

And coming up, what do you have on the agenda?

I'm looking forward to filming new video parts. I love landing new tricks and putting them together for videos. I'll be finished with my bachelor's degree next year, so I'm also looking forward to doing a master's after that. Although, I really want to focus solely on skateboarding and find a situation where I can maximize my time doing it. I need to figure something out. After my master's, I plan on moving somewhere else, something I need to figure out as well. I'm excited to move.

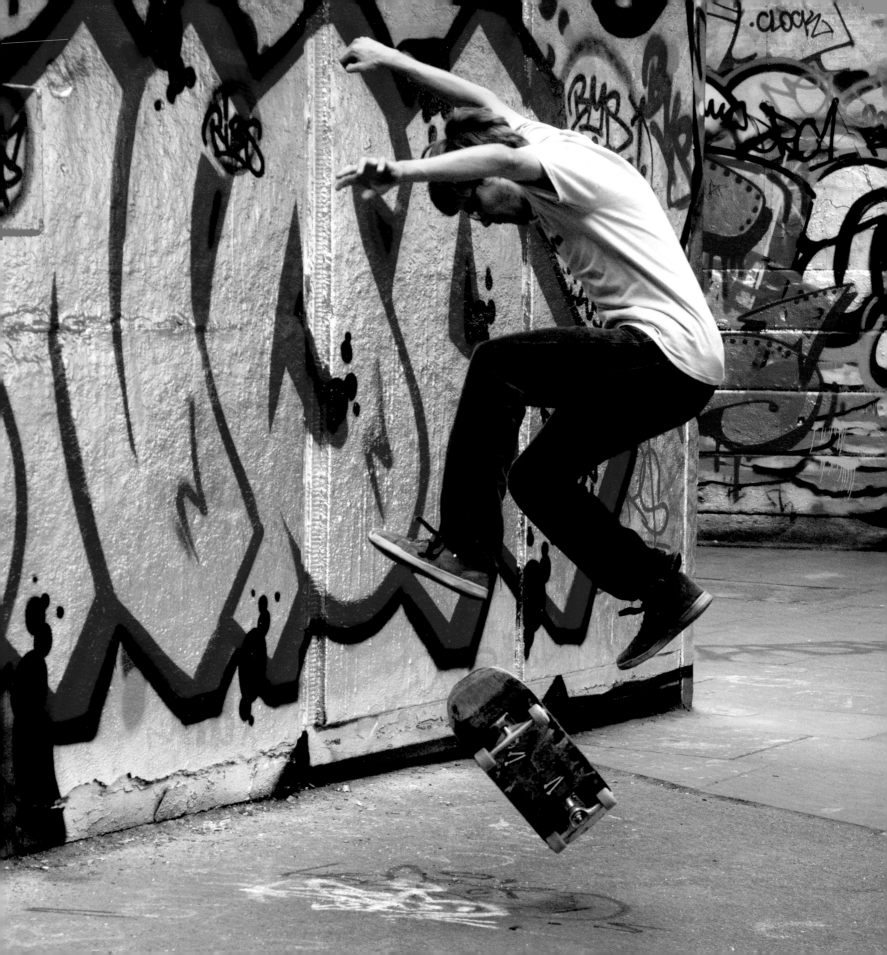

"On the bus I listen to music, some directly taken from skate videos with skating noises still in them."

So juggling university with skating, what does a typical day look like for you?

I wake up quite early, and the first thing I do is make a cup of tea. I usually drink two or three whilst I get ready to go to lectures or labs for the day. Before I have to leave to get the bus, I spend a big chunk of time on the Internet watching skate videos that recently came out. On the bus I listen to music, some directly taken from skate videos with skating noises still in them. I love being able to skate in my mind a situation where I can't physically do it, so I also imagine tricks on the bus. After I'm done with university for the day, I go skating before I have to work on notes or assignments. I work at home. On the bus back home from skating, I review my list of trick ideas, adding and deleting stuff depending on what happened during the session. After I've finished with work, I cook and spend ages on the Internet again whilst eating my dinner, listening to music, watching my favorite skate videos or anything that interests me.

Before I go to sleep I spend time thinking of tricks. I review and edit my lists again and make a plan for the next day. I make the plan the screenshot of my phone so I can quickly look at it during the next day. I write down the tricks I want to try. After that I drink more tea and go to bed. I listen to podcasts and then fall

asleep. I'm currently listening to a podcast that's discussing the old episodes of *The Simpsons*. I'm a huge *Simpsons* fan, so I love it.

You grew up skating in Geneva; do you miss it now that you're in London?

I like skating in Geneva, Switzerland. There aren't many people around, so I can skate without being hassled most of the time. As you say, I live in London at the moment, and it's hard to even roll down the street because it's so busy. I like going back to Geneva to skate because it's so peaceful. It's also a versatile place for skateboarding, very amenable to ideas that require certain obstacles or environments. I can also film more over there because I can put my tripod with my camera down.

So skating is always on your brain; why does skateboarding hold your attention over anything else?

I love trying new tricks. I have so much fun coming up with trick ideas and trying them out. Some ideas work, and others you think would don't. It's a fun process. Whenever I come up with a trick idea that clicks for some reason, I get so excited, and I can't wait to try it. Skateboarding is malleable, and I like that it can be whatever you want it to be. I personally like how there is always something new to try and how sometimes it comes in a random fashion. You never know what is to come, even when you have fixed ideas. There are intrinsic nuggets to be found, and I enjoy mining to find them.

If you didn't skate what would you do instead?

I seriously have no idea. Once you have something you love and know there's nothing else you'd rather do, it's impossible to imagine what you'd do instead. I mean, if I never came across skateboarding in my life, there would definitely be something else I would be doing. However, I have no idea what that could even be given I'm committed to skateboarding because I love it, regardless of skill.

Tell me about your board spec; do you have a favourite deck?

I skate a 7.75 deck with low trucks and 52-millimeter wheels. I skate the products of the people I admire and want to support. I haven't changed my setup in many years; I really like it. I don't like skating big decks because I find them too heavy.

What are your thoughts on the skateboarding industry?

I'm pretty indifferent about the skateboarding industry. I don't know much about it, really. It's cool how people can make a living skateboarding and that companies provide the equipment that skaters need. I guess I dislike trends that the skate industry tends to breed. Either way, I don't think about the skateboarding industry much.

"Even if you can't do something the way you imagine it currently, later on you might notice a way around it, which is exciting."

How did your childhood support your dream to skate?

I grew up in a town called Versoix; it's in the canton of Geneva. I loved growing up there. It's a good balance of rural and urban and doesn't have that many people. I was raised by both my parents. I had a lot of freedom to pursue whatever interested me, so that was cool, and I tried a lot of activities growing up, but as I got more interested in skating I dropped everything else. My parents were cool with that, although they taught me to be respectful and work hard. They let me do my own thing without interfering too much, and they gave me a lot of freedom, which I'm really grateful for.

I remember learning primo slides. I never thought about doing them until a friend of mine said I should definitely try them because I could do them. It took ages, but I finally learned them, and it reminded me that you can actually do something if you just keep at it. Seriously, if you don't dismiss it, there are ways to get there. I've learned to never dismiss something even if it's absolutely insane. Even if you can't do something the way you imagine it currently, later on you might notice a way around it, which is exciting.

What does freestyle skating feel like?

I like a lot of aspects about it. It's nice to go outside and feel the sun when it's nice out. I actually live near this tiny skate park at the back of this small park that I go to every day if I don't street skate. Barely anyone goes there, and it's nice to hear the birds and stuff. I like exploring a lot on the street, too, trying to discover new spots. Scoping for stuff is fun because you never know what you'll find, or if you come back to a place you're familiar with but find a new obstacle to skate, or the same one you skate normally but find a different way to use it, it's so refreshing. There was this one time when I walked by this certain obstacle every day after school but never thought about skating it. One day I realized I could actually skate it. It's funny how you miss something for so long but then suddenly realize it. The smallest observations you have when you're out can change everything.

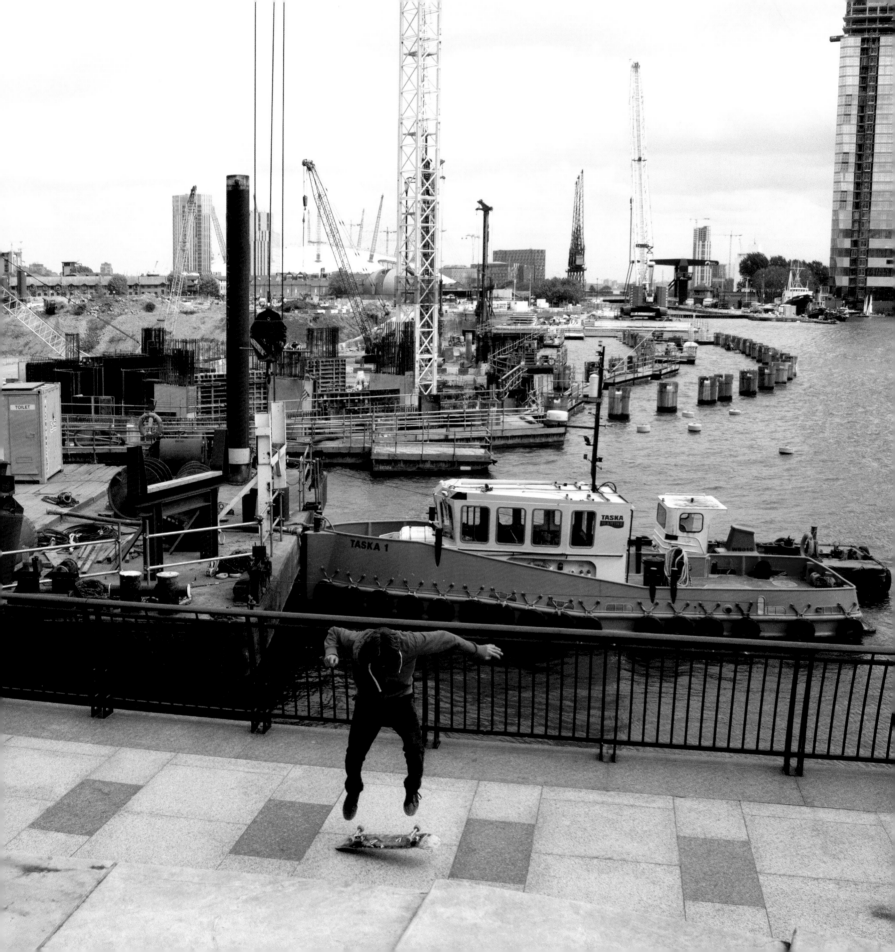

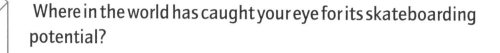

Where in the world has caught your eye for its skateboarding potential?

I'd like to travel to Los Angeles. A lot of people I want to meet and skate with live over there. Also, Japan. From what I've seen, the architecture is really fascinating. It seems like an amazing place teeming with unexpected obstacles to skate. It's also a place I've wanted to visit before I started skating. I want to experience it. Some of my favorite skaters like Gou Miyagi and the Osaka Daggers also live in Japan, so meeting them would be amazing.

When you put your board down for the day, what else do you enjoy doing?

I like playing table tennis with my friends. I used to play it almost every day back in high school. I liked playing it because so many shenanigans would go down; it was absolutely hilarious. We'd play it in an unorthodox way, tricking your opponent doing weird stuff, doing the highest lobs you can do, hitting the ball way out and having the wind curve it back into play, trying crazy spins, quickly swapping a backhand for a forehand, pretending to smash then doing drop shots, pretending to hit multiple times before hitting the ball back at the last moment. Stuff like that. I remember this one time we were trying to get triple lets, and somehow I got two. So random and fun, but apart from the rare table tennis sessions, I don't do any other sports.

What's your biggest struggle?

I sometimes fall into 'nothing traps'. I'm not a lazy person, but there are times where I should be doing something, but I don't. I hate it so much, but when I snap out of those moments, I re-evaluate everything and get stuff back in line.

Action sports, why do you think they're so popular?

I think it's witnessing the crazy things people can do, people doing things that are new to you, that you just don't understand, have no context for but have feelings towards. Creations are cool. I got into skateboarding after watching Rodney Mullen's footage. His tricks amazed me, and from then on I was hooked.

"People say, for example, scootering is lame. Skateboarding is the only way. It's not. People are doing new things in many activities. Respect that and get inspired by it."

Is there an action sport you're keen to give a go?

Probably snowboarding. It seems so fun. I'm fixating on skateboarding, though, so trying other things is something I wouldn't do. It is important, though, to recognize how universal activities are despite differences.

Nothing bums me out more than when people say, for example, scootering is lame. Skateboarding is the only way. It's not. People are doing new things in many activities. Respect that and get inspired by it.

"I would just stand by the stream, completely drenched from trying the trick. We passed it off as an 'art project' and thankfully people just accepted that and moved on."

How much would you say nature plays a part in skateboarding?

Nature is what allows skateboarding to exist. There is a lot of interaction that happens, and I love interacting with what's around and trying to change that constantly. I think about tricks and try find a place to do them or adapt them to fit. I guess it can be viewed in a one-way direction. I do skate spontaneously, but when it comes to ideas, I'm usually trying to exert control, hoping the environment will help me out. I plan and then see. You can get ideas from experiencing the environment itself, usually better ones, but I find that those are rare.

There was a time when I filmed a skateboard trick in a stream. I was so excited to skate something completely random. I walk by this stream on occasions but not that often; however, as soon as I realized that you could actually do tricks in the stream, I was there a lot. The stream is long, so I spent a good time scoping the entirety of it. I eventually settled on trying this one trick, but I wondered if it were possible given the water is in the way of popping the board. When I first tried it, I was surprised by how heavy the water actually was to pop against despite how shallow

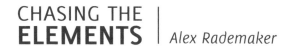

it is. I was also trying it on this pebbly ground, so every time I tried the trick, the surface I was popping on would change. In between every try I used my nose of my deck to dig the pebbles around to make it flat again.

The thing that scared me the most were the people passing by. I didn't want them to see me trying the trick, not because I'm afraid, but because I didn't want them to intervene. It also saved them from trying to figure out what the hell is going on and saved me from trying to explain it. I would just stand by the stream, completely drenched from trying the trick, waiting for people to get out of sight. So many double takes—they were probably wondering why I was so drenched despite me trying to hide it. The few times we were seen trying to film it and approached, we passed it off as an 'art project', and thankfully people just accepted that and moved on. They were so puzzled.

Who inspires you?

I admire people who are doing something new for the pure sake of it. Brett Novak, Richie Jackson, Jason Park, and Gou Miyagi are people who do this. They're my heroes. They're people who do stuff that has never been done before, and that's what I cherish about them. The best new things to me are simple, and these people produce that. That is in no way meaning simplistic in fact; achieving something simple is very difficult and is overlooked all the time. Simple things stare us in the face, and you have to battle to find them and battle to make them a reality.

SOCIAL

| TWITTER | @RADEMAKERSKATE |
| INSTAGRAM | @POOPONUNICYCLE |

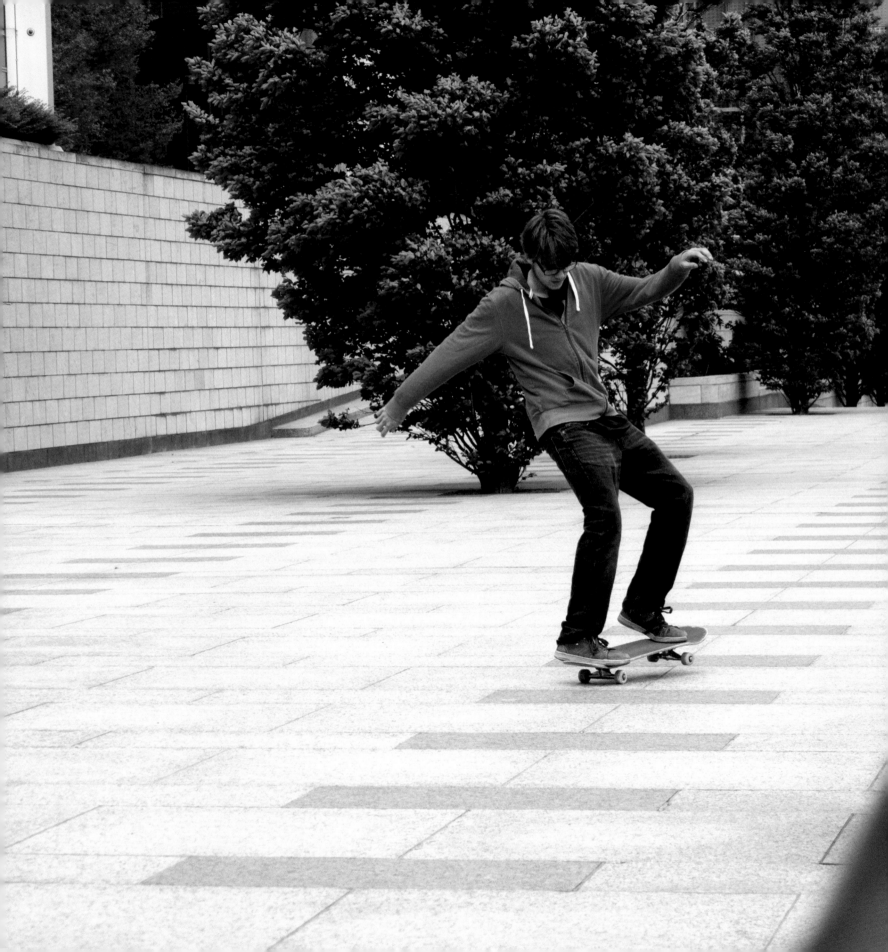

REFLECTION

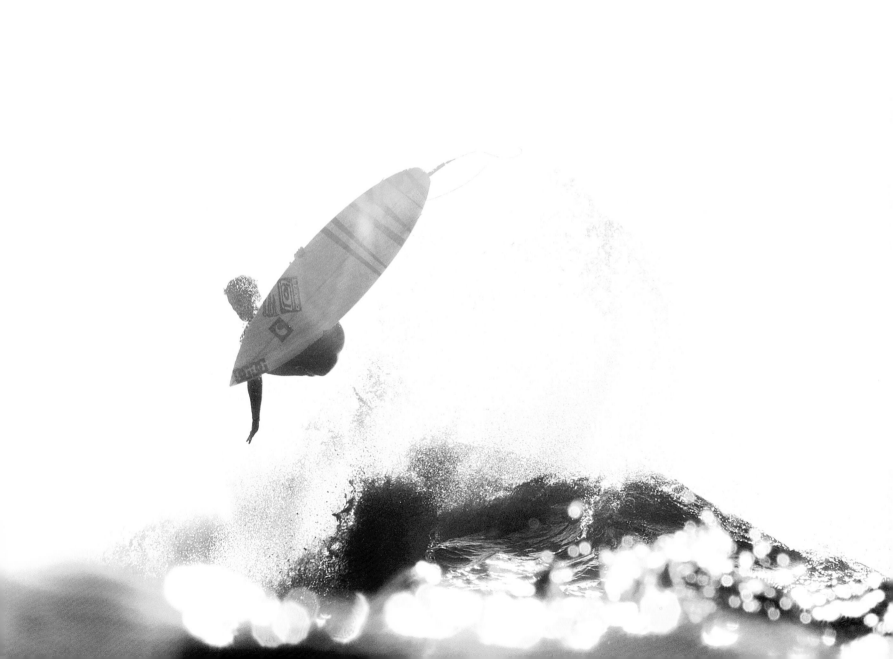

TRANSCENDENCE

The world is being explored by people from all walks of life more than ever before. This is wonderful and plays a large part in creating the sense of a global community. However, it also means that as more of the world is populated and traveled to, less of the world remains hidden for discovery. Team this with responsibilities of our daily lives, turning up at work every day, paying off the car, saving towards a pension, meeting others' expectations of you, it's easy to feel stuck, backed into a corner, in a rut and not living life to the full.

Testing ourselves amongst the elements, experiencing the unpredictability of Mother Nature, forces us to face the raw and stark truth about ourselves. She forces us to be at our very best or face the consequences, and in this way we become closer to the inner workings of ourselves, facing the vulnerability within, feeling the fear but doing it anyway.

"Risk makes our existence healthier and more dynamic."

"Fi yw meistr fy ffawd, fi yw capten fy enaid."

"I am the Master of my fate, I am the Captain of my soul."

—W.E. Henley

What this creates in us adventurists is a desire, perhaps even more of a need, to test ourselves. We search for something that allows us to walk the fine line between an acceptable volume of danger and unimaginable risk. There is a school of thought that believes risk makes our existence healthier and more dynamic.

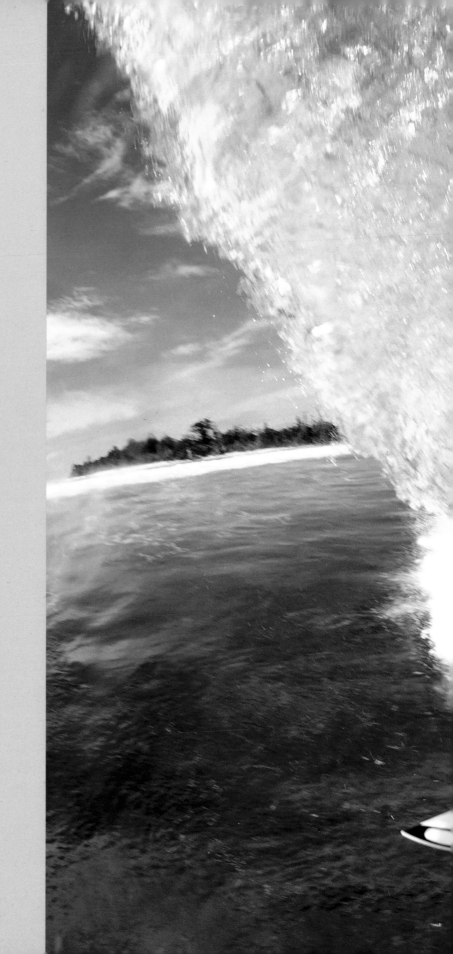

INTERVIEW

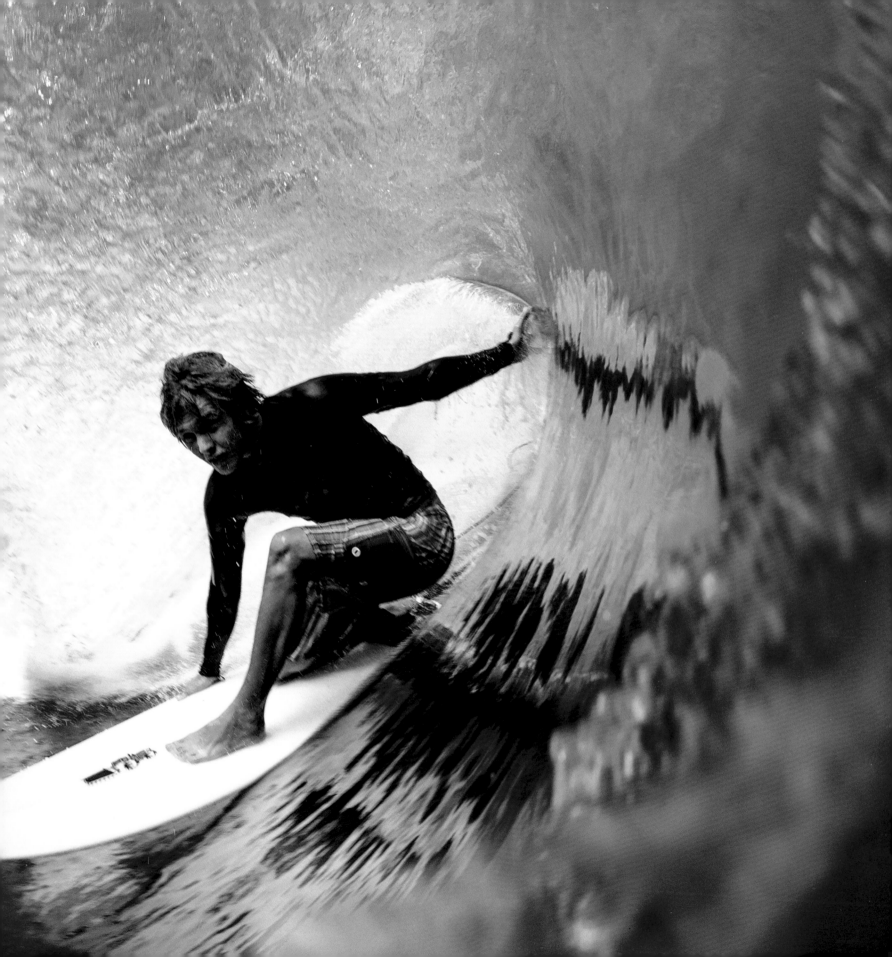

EASKEY BRITTON

BIG WAVE SURFER

"That ability to let go and break patterns of resistance within ourselves...it's the letting go, that I like to think of as 'grace'."

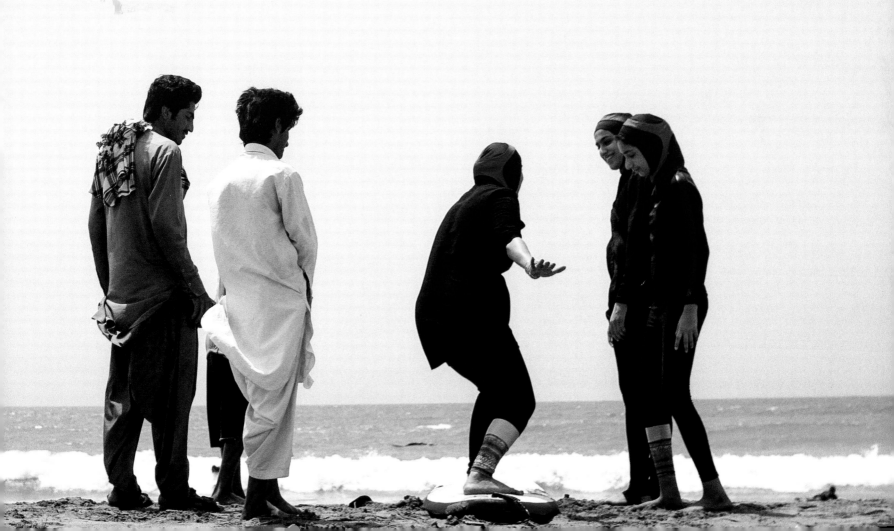

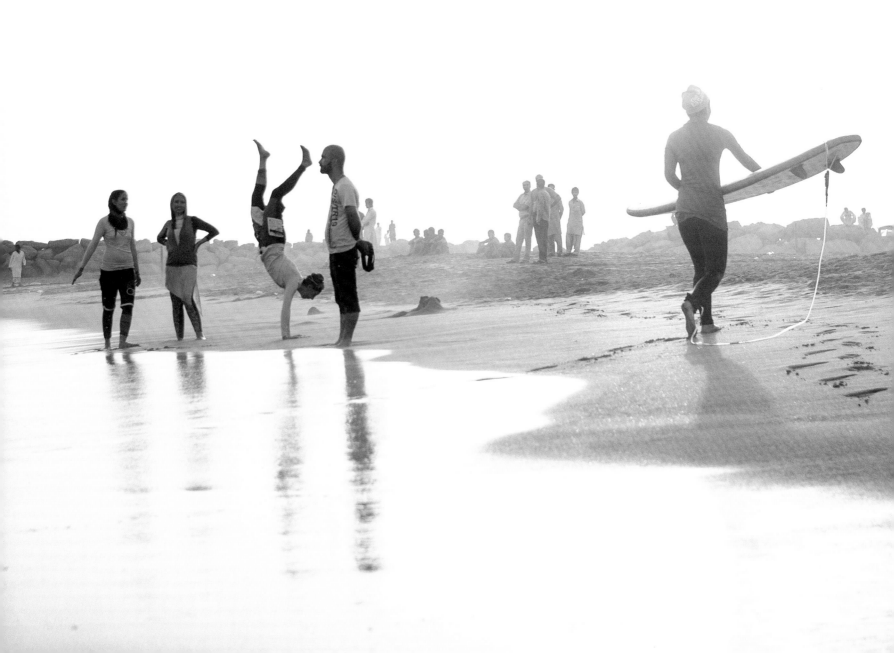

Big wave surfer Easkey Britton is a co-founder of the not-for-profit organisation Waves of Freedom. She uses surfing to inspire social change around the world, most notably in Iran where Easkey was the first female to ever surf Iranian waters. Easkey explains:

'Iran has such a rich and intriguing culture as the former empire of Persia, the centre of civilisation in the ancient world. People thought I was mad, of course. Sure, I did my homework tracking swell patterns and mapping the coast for potential spots and the water temperature (hot!) but knew little about the history, culture or politics. Which is probably just as well because some media publications claim it is the scariest little corner on earth.'

Easkey has also launched the Surf + Social Good Summit, the first of its kind in the world and hosted in Bali, Indonesia. She's the cold water surf ambassador for Finisterre, five times Irish National Champion and a Big Wave World Surf League nominee. I ran questions by her as she gathered her thoughts whilst staying at a collective art space on Maui in Hawaii.

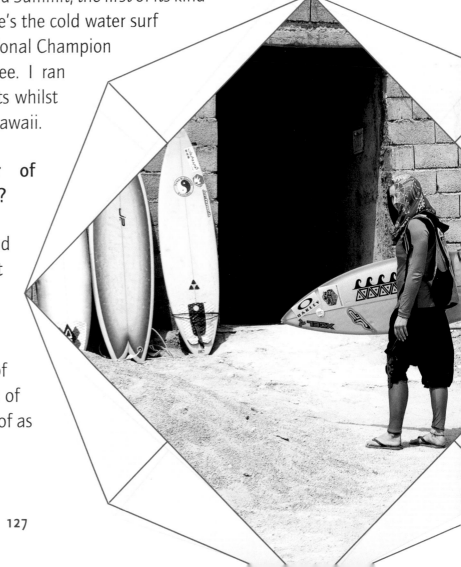

You've had an incredibly busy year of accomplishment; has it felt that way to you?

2015 was my 'year of grit', challenging and transformative. I'm most proud of how I let go of what was no longer serving me well in order to make space for what matters most and to more confidently declare who I am. That ability to let go and break patterns of resistance within ourselves...it's this last part of the process, the letting go, that I like to think of as 'grace'.

What does the near future look like for you?

I've distilled the next few years into core values to help guide my creative process: freedom, mindfulness and grace. I'm excited to explore and experiment what they mean for me and how to embody them through life and living. They are values or lessons that I've learned through surfing and the sea. And they're the core themes of a book I'm working on; finishing it and putting it out in the world is a major, concrete goal!

You've always cited your homeland as being your favourite place to surf. Is that still the case?

I'm such a nomad, but yes my favourite place to surf is still at home, on the Wild Atlantic Way in Ireland.

> "My name, Easkey (or, 'Iascaigh'), has its origins in the Gaelic for 'fish'."

What was your childhood like?

My name, Easkey (or 'Iascaigh'), has its origins in the Gaelic for 'fish'. It's also the name of a world-class surf break on the west coast of Ireland. It's a right-hand reef-break next to the ruins of a castle, my parents' favourite wave. Imagine if I didn't like the water! Easkey is also one of the first places I learned to surf over reef and where I

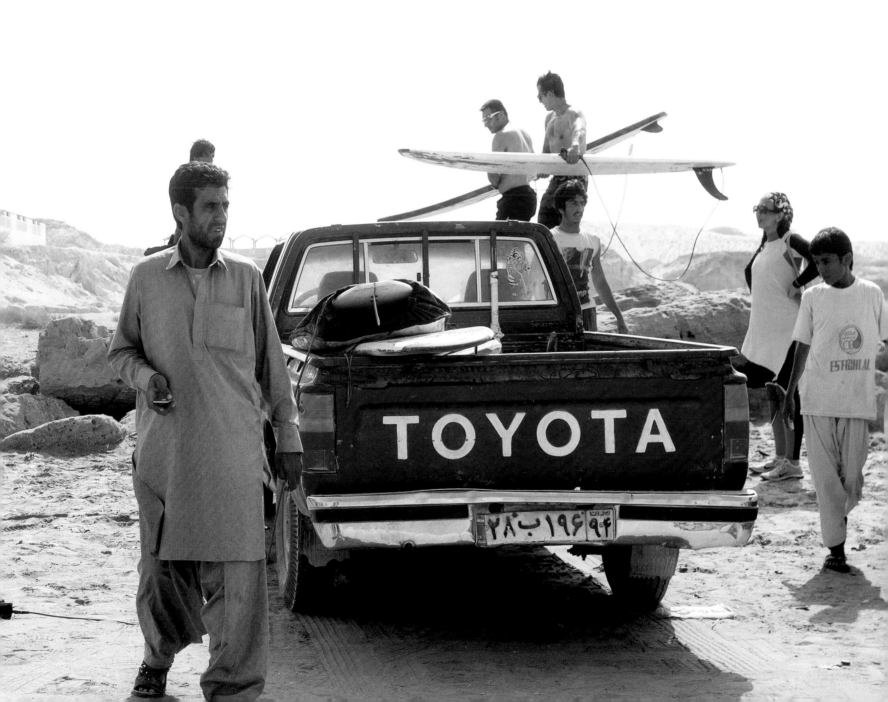

began to hone a taste for more powerful waves under the mentorship of the local and traveling regulars who camped out on the coast seasonally or full time. They adopted me as their own in the line-up and shared their water knowledge.

As a kid we'd go on family roadtrips to my namesake and camp next to the surf break. My little sister and I curled up between our parents in the back of the van, listening to the waves crashing on the reef. At first I learned about the reef, the swell and tides from my time spent in rock pools observing what the sea left behind when it receded and watching them fill in as dad timed his surf for the pushing tide. I would try to make my getaway across the slippy green seaweed we called 'mermaid's hair' before the sea filled in over my little red wellies. It wasn't long before I followed my dad out there.

From my mother I got a passion for travel, for seeking and trying to understand what was beyond the horizon—one of the things I love about surfing is the constancy of the horizon line—through different worldviews, spiritual traditions and by going on epic journeys together from a young age.

It sounds like every child's dream. What do you enjoy most about the ocean now that you've left childhood behind?

The freedom, respect and humility that it teaches me and more than a little awe and wonder!

Is there a particular corner of the earth you'd like to disappear to?

I've had the amazing privilege to be able to travel from such a young age and live a semi-nomadic lifestyle, and it's been mind and heart expanding for me, but to be honest, I feel I could explore a lot more in my own backyard in Ireland. That excites me more and more, to see the familiar in a different way, instead of always chasing new and 'shiny' experiences.

What do you have to remind yourself of inwardly as you go through life?

That my energy is not infinite; it needs to be renewed. Remember to slow it down, pause, breathe, be kinder to myself; there is tremendous strength in vulnerability.

What's your fondest memory of experiencing the power of nature?

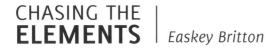

So many...I love finding moments of gratitude in nature every day; cultivating the art of noticing and being curious is such a good way to engage with the nature all around us however great or small, wild or urban. But one of the biggest and most powerful memories is from the ocean on a big wave day at Mullaghmore. One of those rare moments, in the middle of a storm when the wind dies, just before sunset, in the middle of winter and all the elements align unexpectedly, and you're right there...just a small crew, 30-foot swell, no buzz or crowds. Just a couple of good friends tapping into the tremendous energy of the ocean detonating on a small dark slab of rock off a remote headland. Despite the fury of the sea, it was the first time I felt like I belonged out there. There was no doubt.

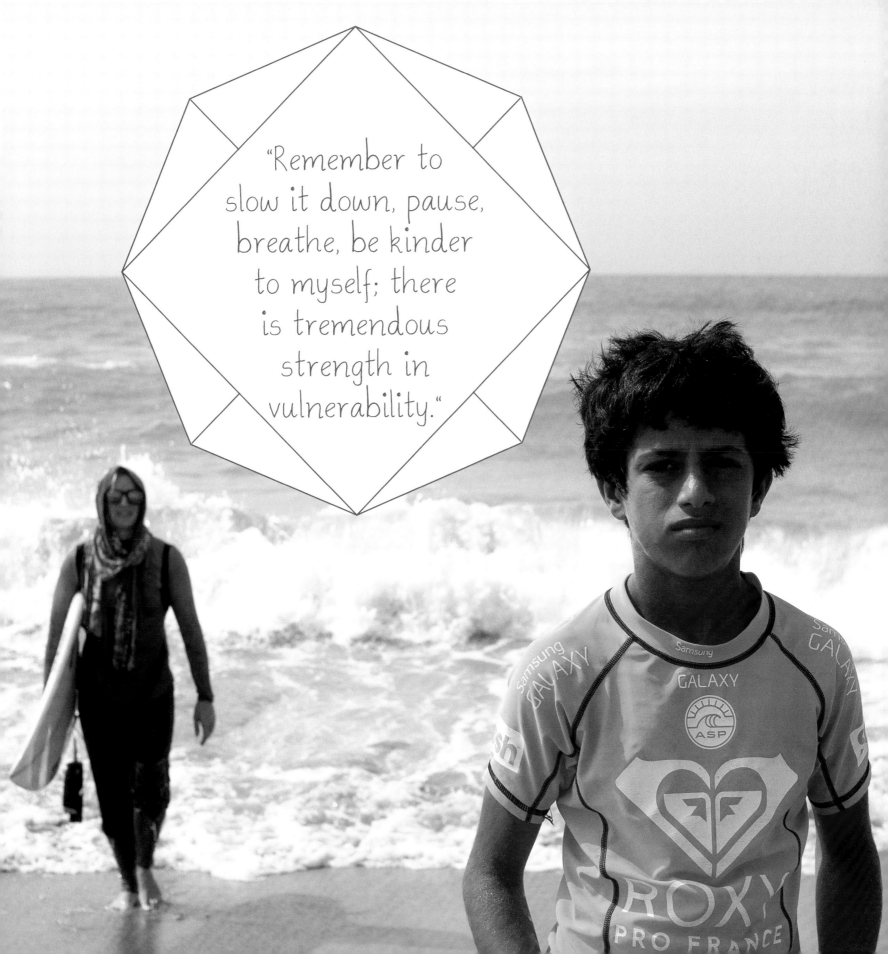

"Remember to slow it down, pause, breathe, be kinder to myself; there is tremendous strength in vulnerability."

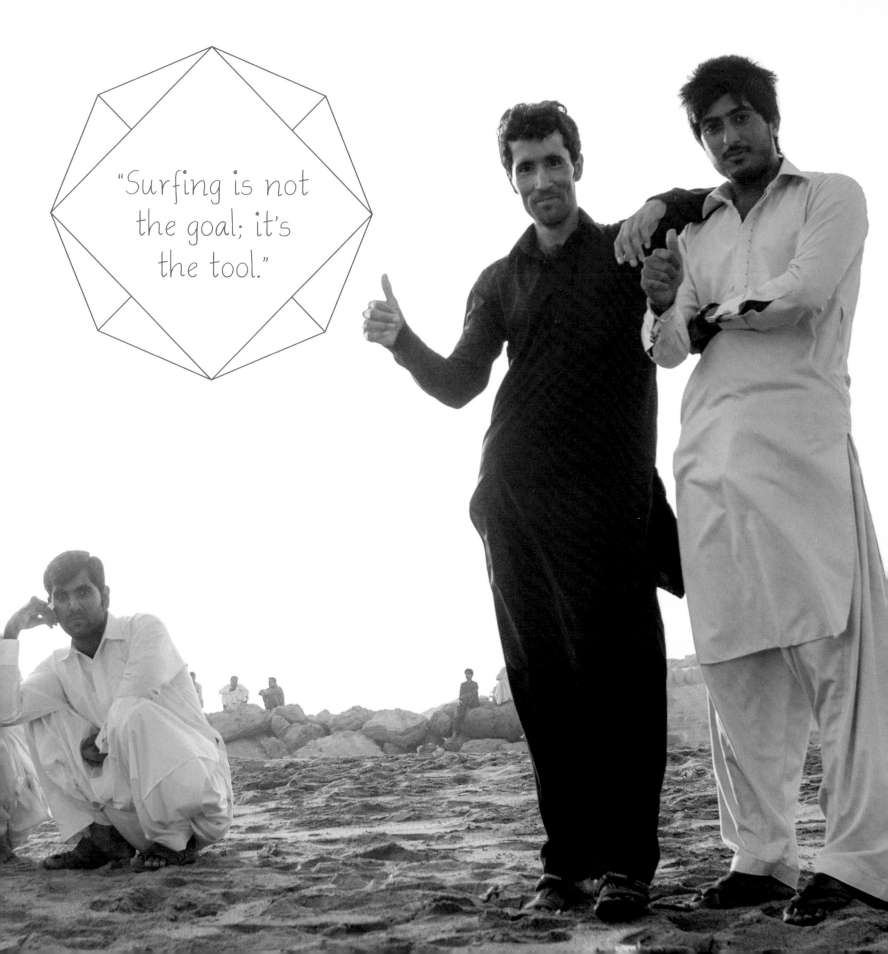

"Surfing is not the goal; it's the tool."

What motivated you to co-found Waves of Freedom?

It's hard to distill what has become such an unexpected, ever-evolving, long-term journey; a meshwork of relationships; a diversity of interwoven perspectives; change-makers; breaking barriers; creating new ways of knowing, doing and learning.

Waves of Freedom is a voluntary-led non-profit that explores how surfing and the sea can be used as a creative medium for positive social change and global connection across cultures.

It was born from the realisation of the need to deepen our understanding of what we'd experienced with surfing's ability to connect in the most unexpected ways and in an unlikely place like Iran. The turning point was sharing the surfing experience with other like-minded young women in Iran, who became the first surfers in their countries. So, essentially, surfing in Iran was initiated through women, which is a powerful thing given the history of women in surfing and the issues women face in the Middle East in particular.

It inspired a shift in our relationship with surfing and how it could be used as a vehicle or platform for creating connection and addressing deeper social and ecological issues. It's been a constant learning process and, as a result, forever evolving. At the core is understanding the impact of surfing and the sea, especially for women and girls, and its potential to empower.

What we do has expanded beyond Iran, although our collaboration with the fledgling surf community there is long term and ongoing, to work with other people, institutes and organisations around the world, a growing 'surf for social good' tribe.

Surfing is not the goal; it's the tool. The social issues we witness and experience are a lot more shared than we realise, and we're working on taking this learning back to our grassroots, which, for me, means to Ireland, especially in terms of reconnecting with the nature/sea for our well-being and ocean health.

SOCIAL
WEB WWW.EASKEYBRITTON.COM

TWITTER @EASKEYSURF - @WAVES_FREEDOM

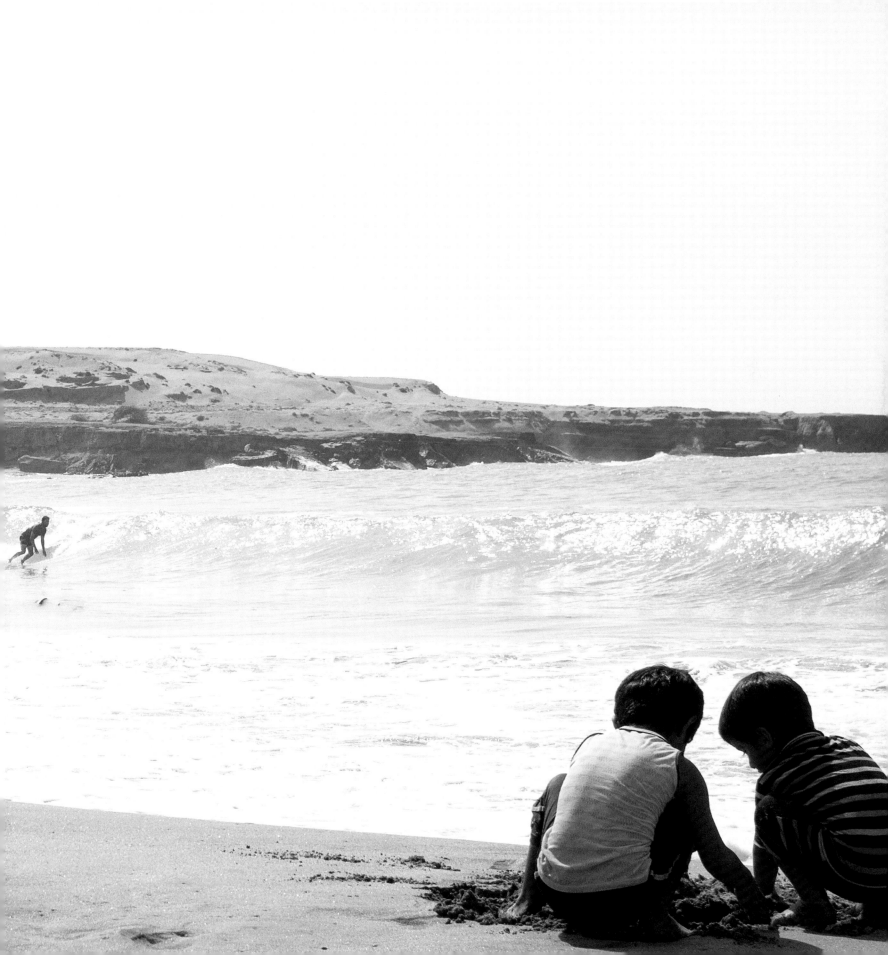

INTERVIEW

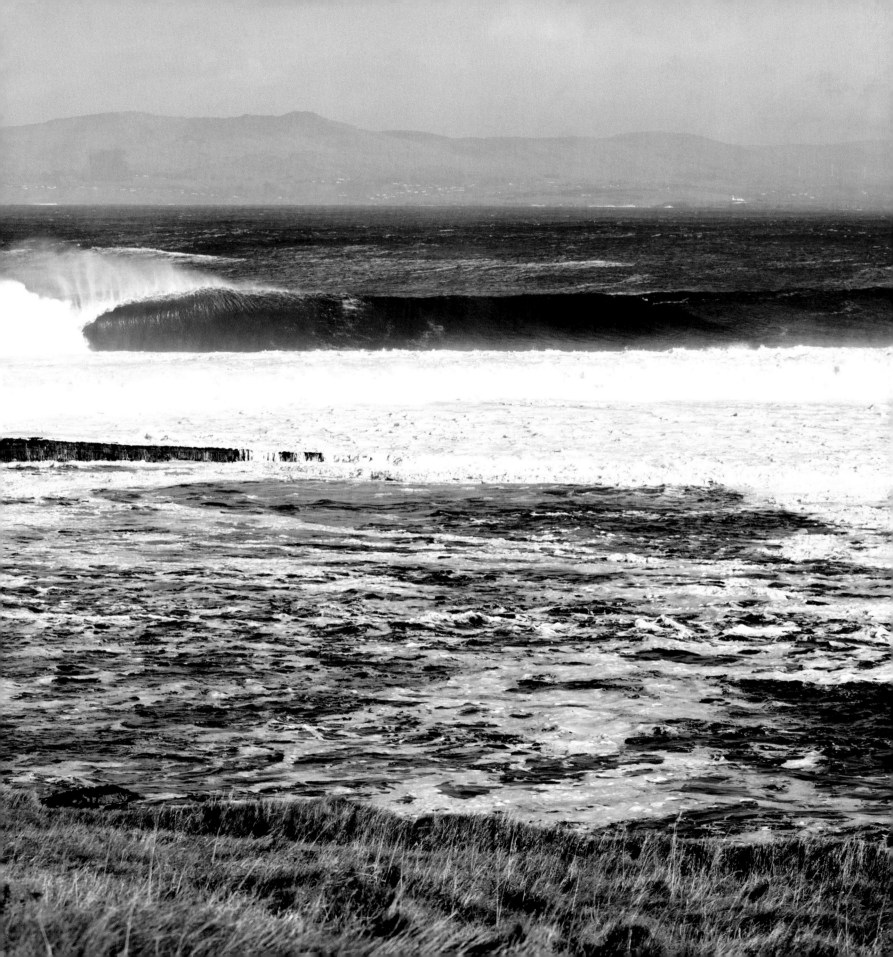

HERBERT NITSCH
PRO FREEDIVER

"Each time I think I've reached
a limit...there is a door...it opens...
and the limit is gone."

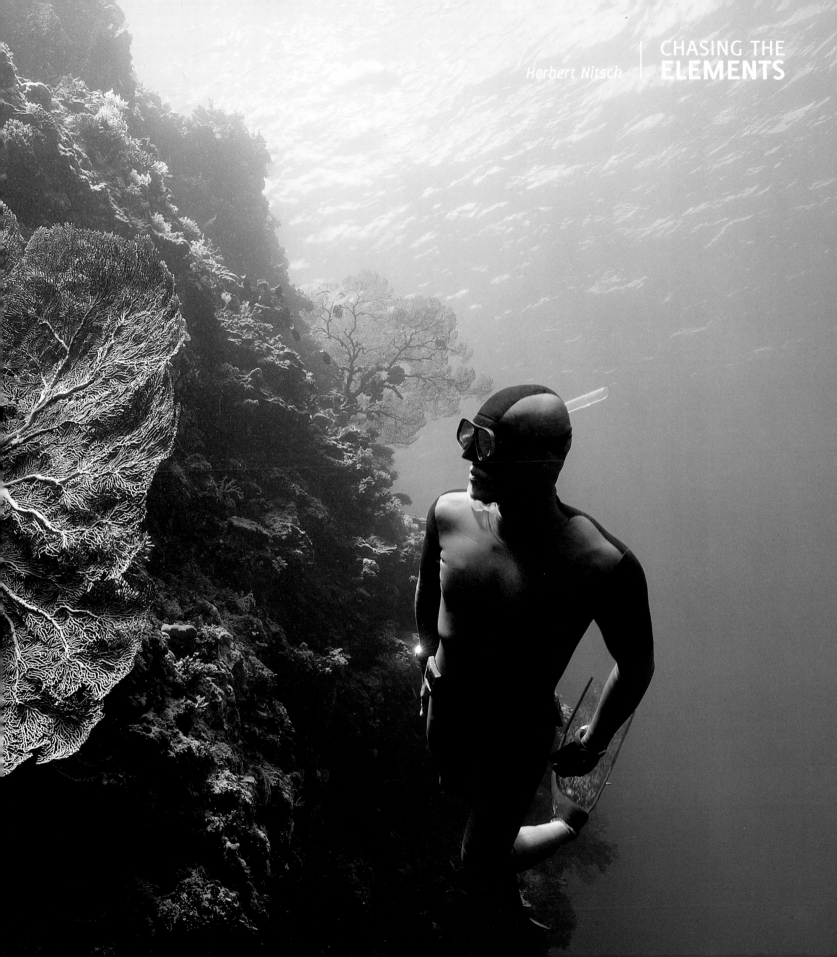

CHASING THE
ELEMENTS | *Herbert Nitsch*

Austrian Herbert Nitsch is the current freediving world record holder, a self-taught man whose primary claim to fame is being the deepest diving human on the planet. His willingness to test the boundaries of physical capability have led to some life-threatening situations, yet in 2012 after freediving for several years, he set the current world freediving record with a 'No Limits' sled dive, taking lungfuls of air at the water surface, then diving without any breathing equipment to a world record depth of 253.2 meters, or 830.8 feet. An incredible feat. Herbert is the holder of 33 freediving world records and can hold his breath for over 9 minutes.

Renowned as the go-to freediving guy, Herbert has been interviewed for *Red Bulletin, Men's Health, GQ, Playboy, ESPN* and appeared on several TV shows and documentaries for the likes of *CBS 60 Minutes Sports* and the *BBC*.

In the late nineties, Herbert was travelling to take part in a scuba dive safari when he realised that his scuba equipment had become lost in transit. Unable to do anything about it, he arrived at his destination with no kit and had no option but to snorkel instead. This gave Herbert the opportunity to freedive for the first time, and he soon discovered that not only did it ignite a passion, but it unearthed a world class talent, too.

I caught up with Herbert as he sat on the sofa in his apartment in Vienna, enjoying the views of the river Danube. Due to his training schedule and world-record attempt dives, he's not at home much, so I caught up with him having some downtime in between trips.

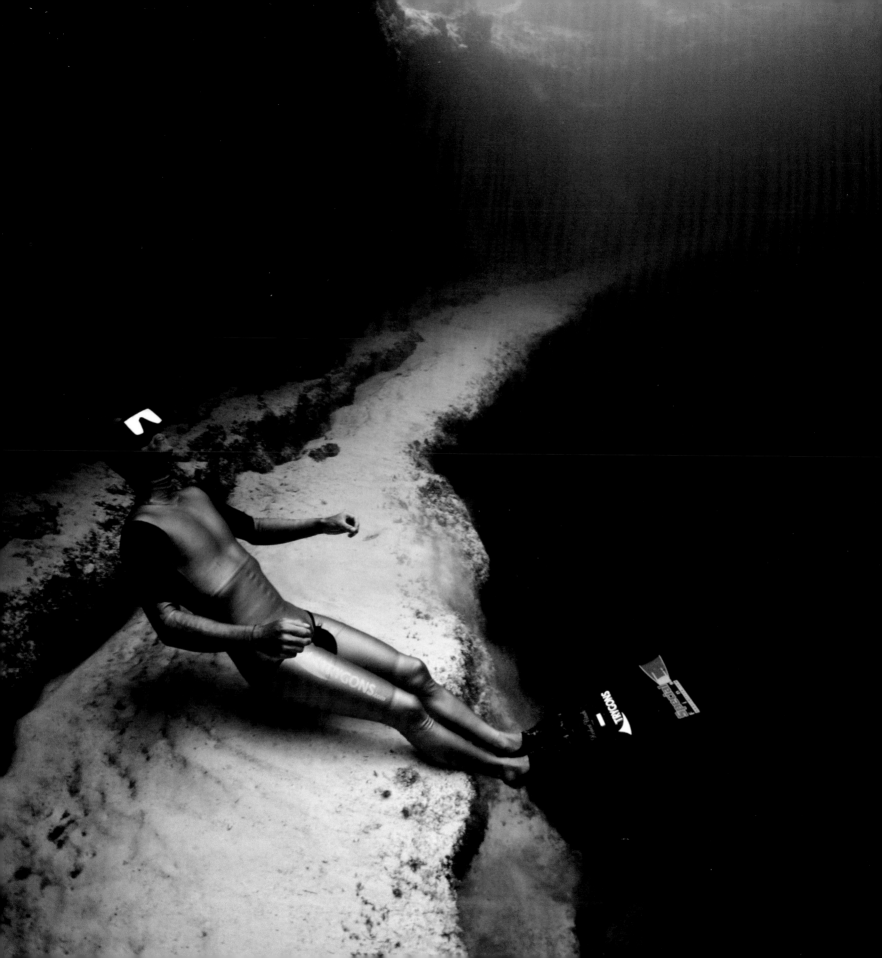

CHASING THE
ELEMENTS
Herbert Nitsch

You've got a little time before you head out to dive again; what have you been up to since being at home?

I'm working on the designs for my ocean-going eco-boat which I plan to live on once it's completed, and I'm nearly finished with writing my autobiography, which was by far the most difficult thing I've ever done in my entire life.

You have to train a bunch to keep your body in tiptop order; what does training look like for you?

I keep fit throughout the year with muscle, endurance and specific flexibility exercises. When going on a freedive trip or preparing for a competition, I do particular breath-hold training for about a week prior to that. Contrary to most competitive freedivers, I completely stop breath-hold training in between trips, as I believe that it is not good to continuously expose your brain and your body to oxygen deprivation.

What are you most looking forward to in the near future?

Blue water sailing, publishing my books, holding some fun lectures, and doing some specific freedive and marine-conservation projects.

What does a typical day look like for you?

If I'm ocean side, my day starts with kissing my lady awake and bringing her breakfast in bed, after which I'll be doing the laundry. But for some miraculous reason, I quite often actually forget to do everything except the kissing part, which is followed by a dip in the water for a few hours

of fun freediving, including often doing some underwater filming. After that you'd probably find me tinkering with my boat design on my computer or preparing for a project or a lecture. If I'm at home, my day is similar, but instead for freediving, I'll be doing my fitness routine. At home I have a stationary recumbent bike, a cross-training machine, and weights. I bike everywhere in and around Vienna, no matter the distance. I believe it is very important to maintain a good overall fitness level, both in musculature and endurance. It is not necessarily related to freediving. When at sea I play in the water to keep fit.

What is it about freediving that motivates you to get out there and push yourself?

The great motivation for freediving is exploring the boundaries of my physical and mental being. It is this exploration, this journey into the unknown, that intrigues me. Because each time I think I've reached a limit, there is a door, it opens, and the limit is gone.

What is it about freediving which you find most difficult?

Believe it or not being out of the water, the act of breathing can feel like an effort. Breathing is overrated.

If you weren't a pro freediver, what do you think you'd do instead and why?

I was a professional pilot before and during most of my freediving career, I stopped flying in 2010. But, I was always very active in sports. As a teenager you couldn't get me off my windsurfer, and

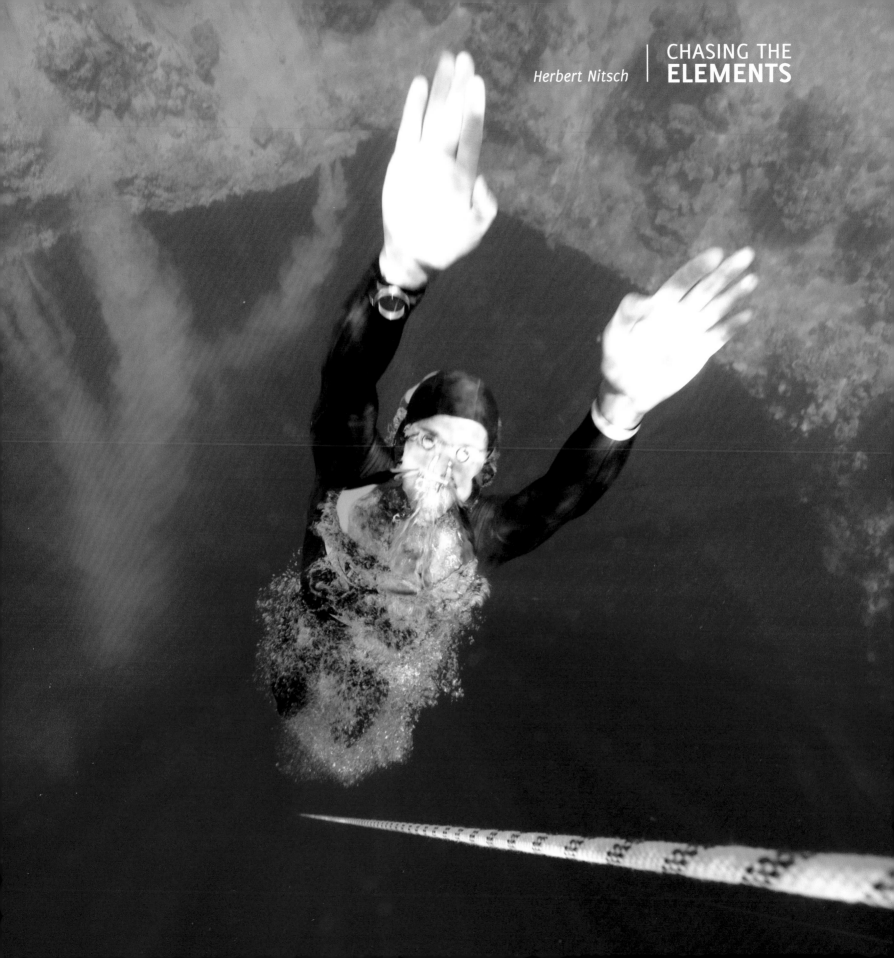

Herbert Nitsch | CHASING THE **ELEMENTS**

"Remain humble, no matter what you do in life."

I was on the school's swimming team. Water skiing and inline-skating were also part of my agenda until late into adulthood and I'm still passionate about sailing and biking. So I would probably still be a pilot, albeit a very sport-focused one.

Where is your favourite place to dive and why?

It depends, for a bit of freediving fun and to capture the beauty of marine life in the deep blue, Palau and French Polynesia are magnificent. For competitive freediving, Dean's Blue Hole in Long Island, Bahamas is fantastic. For No Limit freediving, which falls outside of the competition world, several places in Greece are splendid.

Tell me about where you grew up and how you were raised?

I was born and raised in Vienna, Austria. My parents were both into sports and we were always holidaying on or near the ocean, which probably added to my interest in physical pursuits and passion for water sports. Upbringing is a collective good of the environment you are raised in and the people you interact with, it forms part of who we are and the rest you have to figure out yourself. Maybe in my early days my parents played a more important role, but I was not conscious of that because I was a little kid. I do, however, remember one particular lesson my father taught my brother and me and that was to remain humble, no matter what you do in life.

What are the most important things your family taught you?

We are taught many things consciously or subconsciously by our family members, teachers, friends, colleagues, strangers, and also by animals. It is hard to say who exactly was responsible for teaching what. I think what's most important is what each individual does with what he's taught.

So much of your life focuses on the ocean; what do you love the most about it?

That it is endlessly deep and endlessly large and that it has relatively few people on it and in it.

Which destination is on your freediving bucket list?

Freediving with the greatly varied marine life in the Galapagos must be amazing. I'd also love to dive into the deepest part of the Marianna Trench using a submarine, as it is even less explored than the surface of the moon.

Where in the world would you like to head to and disappear for a little while?

Somewhere surrounded by pristine waters filled with abundant marine life. The inhabitants of this place would treat each other and the earth, with the greatest respect. I bet you that Sir Thomas More has been misleading us about the location of Utopia in the Atlantic, so I'll build my boat and set out to find it. It's got to be somewhere on this planet, right?

What other sports do you like to do?

Anything involving water, or anything on wheels without an engine.

Do you have a favourite childhood memory?

During a family trip to the Maldives, my father and brother were scuba diving as they had licenses. I was too young to get one at the time, and the dive club in the Maldives also had a minimum age requirement. Nevertheless, I always tagged along on any scuba trip with my father and brother. I would snorkel on the surface and usually try to swim down to their group below.

On one excursion an instructor saw me snorkelling down to the scuba divers who were at 10 meters, (33 ft) or so. He probably realized that I was comfortable with a mask, fins and equalization, and when he came back to the surface, he handed me a scuba tank which only had a regulator attached. I got a very quick introduction, "breathe through this", from this non-English-speaking instructor, then he said, "meet you at the bottom". I was as happy as a kid in a candy store.

What advice would you give to your teenage self?

That there are no limits to what your mind and body can achieve. It is a pity that kids never learn this at school. They should be taught how to use their bodies and their minds in the most efficient way to realize whatever aspirations they have. Human beings manage to live their whole lives without understanding anything about themselves and their potential.

"I overheard
doctors
say, 'he'll
be a basket
case in a
wheelchair.'"

What's the biggest dream for your freediving career?

My biggest dream morphed from one thing into quite something else. Originally, my biggest dream was to "No Limits" freedive to the magic number of 1000 feet, because I was, and still am, absolutely convinced that this is humanly possible. I, therefore, set up a series of attempts: 600 feet, 700 feet, 800 feet, etc. The one unexpected event that happened during my deepest "No Limits" dive to date (253 m/831 ft) was that I temporarily fell asleep due to nitrogen narcosis, so I missed my in-dive decompression stop on the same breath-hold. This meant that severe decompression sickness set in 10 minutes after the dive. Many symptoms of severe decompression sickness can take up to 24 hours to appear, and in my case, it revealed itself as multiple strokes in the temporal lobes and cerebellum. That was tough because it shows that no matter the thorough preparation and safety systems, something unforeseen can still happen.

How do you plan and prepare for something that has never happened before?

So who knows what other surprises there may be when attempting even deeper depths? When I was in the hospital after having the strokes, I overheard doctors say, "he'll be a basket case in a wheelchair." Once I'd heard that, I had a new dream, just as big as my freediving dream, which was to prove the medical experts wrong. I was most certainly not planning on remaining a care-dependent patient for the rest of my life. As soon as I could, I checked myself out of long-term facilitated care to focus on healing myself. Six months later I was walking again. Two years later I was deep freediving again.

"We, ourselves, are ultimately the experts
of our own lives and life experiences."

Your story of recovery is remarkable. What's been your outlook on life since?

The decompression sickness, the strokes, and the prognosis of remaining wheelchair-bound taught me two things. One, that the medical profession knows very little about the body's self-healing capacity, and two, that anything is possible no matter what the odds. I have been told many times by "experts" that certain things were impossible, from diving to certain depths, to building my last "No Limits" sled, to self-healing and being a fit human being again. So I highly question any expert advice these days. We, ourselves, are ultimately the experts of our own lives and life experiences.

That's such a powerful message. What is it about the nature of extreme sports that draws people to them?

People practicing sports that are perceived by the general public as "extreme" are exceptionally aware of themselves and their environments. They understand the risks and challenges involved and minimize these by taking precautions, training, planning, thinking, learning, and adapting. They do these sports because of the fulfillment they feel when following their passion, which adds an additional dimension to the journey of life. By being fascinated with how much they can push their limits and move boundaries, these men and women become pioneers. From time to time some pay the ultimate price for it, but at the very least they pay that price doing what they love. As the saying goes, "Everyone dies, but not everyone lives."

"Everyone
dies,
but not
everyone
lives."

Being in nature is a massive part of your life; tell me about that.

During my many dives all over the world, I've noticed the incredible pollution and results of overfishing. Our beautiful oceans, which cover the vast majority of our planet, are in a concerning state these days, and very little is done about it. The international waters outside countries' territories are a free-for-all that is hard to monitor and control. So-called international agreements about whaling, for example, and fish quotas are theoretical and bureaucratic masterpieces that have little meaning in practice. Most people don't realize this, and something has to be done.

I am a very proud member of the Sea Shepherd Ocean Advocacy Advisory Board, which is a leading force in creating awareness to the mainstream public about the state of our oceans and its marine life. The effective actions of many volunteers and contributors encourage people to do more to help. In my own small way, I hope to contribute by dedicating time to spread the word about this noble cause whenever and wherever I can.

You're preparing to conduct more conservation projects, too, aren't you?

Once the ocean-going eco-boat I'm currently designing is ready for the water, my plan is to work closely with researchers by taking them to remote areas, which are otherwise almost impossible for them to reach, to learn and share information about the state of the oceans. Meanwhile, I spread the word about the important work of the Sea Shepherd Conservation Society, and partake in some of their projects.

Your lifestyle and goals sound really exciting, but what is it about life which makes you melancholic?

It would make me very sad to be sailing around the planet without ever finding something that resembles Utopia. We are supposed to be such an intelligent species, it would be hard to imagine that with all our brainpower we couldn't manage to create such a place. I would be

even more sad to realize at the end of my life, that Homo sapiens are actually no more than a bunch of materialistic, power-hungry, earth-destroying, warmongering knuckleheads.

Which characteristics do you most admire in others?

I admire specific qualities of different people. I admire things people have done or have accomplished. This could simply be a gesture, a positive mind, an invention, or an achievement. I'm inspired by Nikola Tesla for his brilliant inventions, Hans Hass for opening the magnificent underwater world to us, James Cameron for showing that the depths of the Mariana Trench can be explored single handedly, Umberto Pelizzari for sharing the sport of freediving with a worldwide audience, and Boyan Slat for his innovation to clean plastics from the oceans.

You taught yourself to freedive, and you've adapted proven freediving techniques, resulting in your own style of freediving. It's a brave thing to do when you've already had serious strokes from freediving; what compels you to continue?

The way I see it is that to constantly improve my freediving techniques I need to listen, learn, and innovate. Listening to other people's ideas is essential, whether they're young guns or old foxes, simply because one idea or suggestion can lead to an epiphany. For example, I have a very particular equalization technique that I use; the seed for it was planted by a comment from a newbie freediver. Equally as important is to realize that old foxes don't know everything. When you follow the path that others have taken before you, it's hard to be better than them. You have to learn what works best for you, and you have to learn to understand your own body. Most

of my freediving techniques and innovations are unconventional and controversial, but they have proven to be very efficient and effective. If you want to outsmart the competition, you have to be a pioneer and not be afraid to make an ass of yourself. So when you do decide on something, visualize it, believe in it, and go for it. If it fails, try again, because it's better to fail and learn than to not even try.

Are you surprised about how much your body is able to endure?

Rather than the word *endure*, I prefer the words *achieve* and *perform*. It is amazing what your body and mind can achieve far beyond your perceived limits, especially with freediving, where big strides can be made in a relatively short time period. For example, everyone, yes everyone, can double or triple their breath-hold time within one week with special training of about an hour each day. Imagine being able to run twice or three times as fast within a week, that would be quite something if that were possible! Freediving is so interesting as you can move boundaries so incredibly far. I'm always curious where the next dive will take me.

What would your primary piece of advice be to someone starting out in freediving?

Believe that you can do it, and you will be surprised of where your body will take you. That, and always freedive with a buddy.

SOCIAL
WEB WWW.HERBERTNITSCH.COM
TWITTER @HERBERTNITSCH

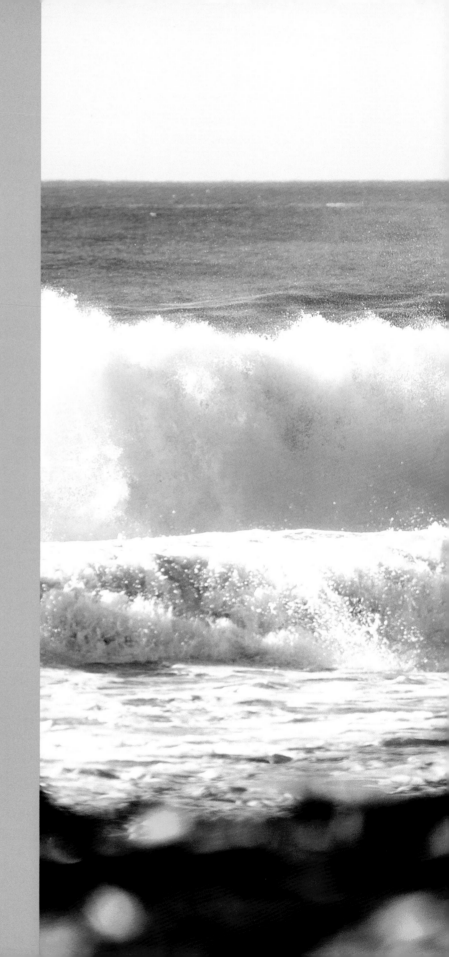

INTERVIEW

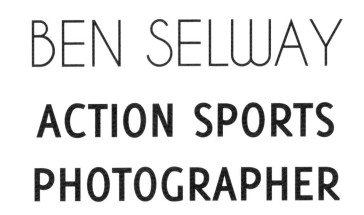

BEN SELWAY

ACTION SPORTS
PHOTOGRAPHER

"Surf photography is where my heart belongs."

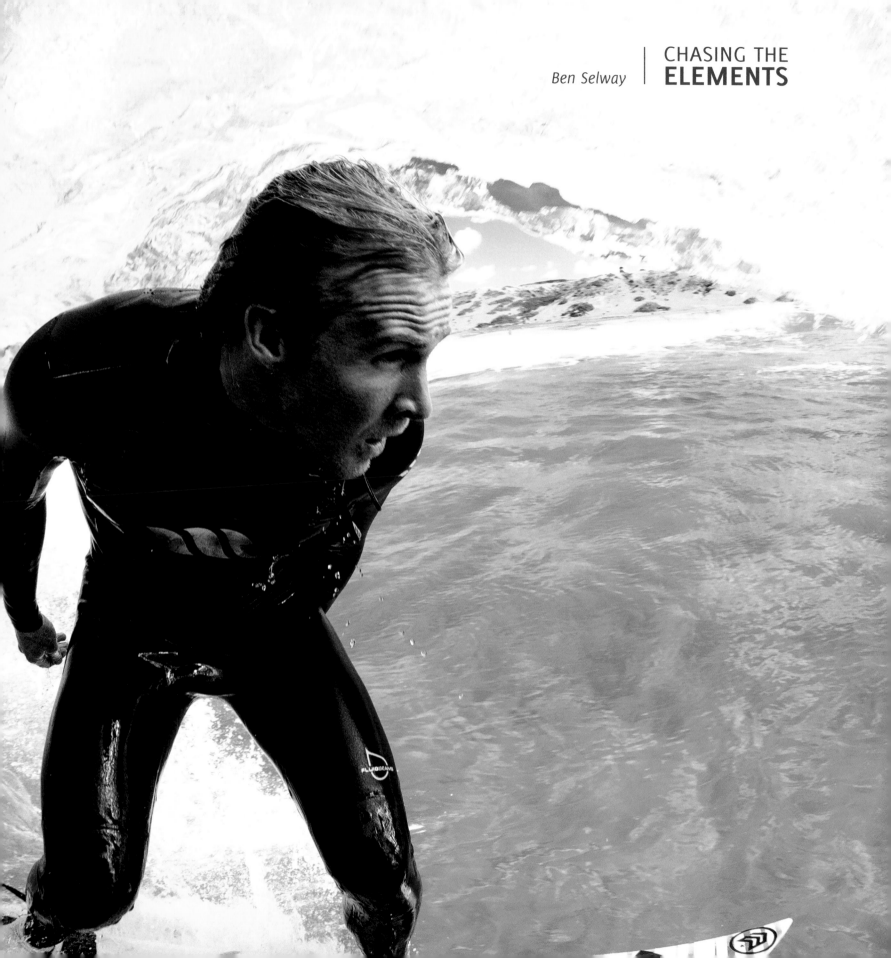

Ben Selway

CHASING THE ELEMENTS

Ben, a great friend and fine art photographer, travels the world photographing the most beautiful waves and creative surfers, immortalising the spirit of action sports with the soul of nature.

I call Ben 'The President'. There's something tenuous going on in my head to do with Benjamin Franklin being the 6th President of Pennsylvania, their sharing a first name and Ben (the younger) being at the top of his game. His wife also responds favourably when I call her 'The First Lady'. They're comfortable with the aliases I've given them.

From his hideaway in Feock, Cornwall, we spent some time talking surf, inspiration and cameras.

What draws you to surf photography in particular?

There are so many different factors that generate interest for me. I guess the overriding factors are that I love capturing a moment, whether it's in the water, on land or whatever I am shooting. Freezing the moment for eternity is quite a special thing to do. Secondly, I love the feeling of getting a good shot and seeing other people's reactions to it, especially the subject's. Fundamentally, though, even with 10 frames per second at your disposal, there's something quite special about creating a single image, or single set of images.

Surfing is my favourite subject matter. I know it sounds cheesy, but I feel at home in the ocean or next to it. I especially love swimming around with my camera and trying to capture the action from the surfer's perspective. I do love lots of other types of photography like landscapes, street and portraits, but surf photography is where my heart belongs.

162

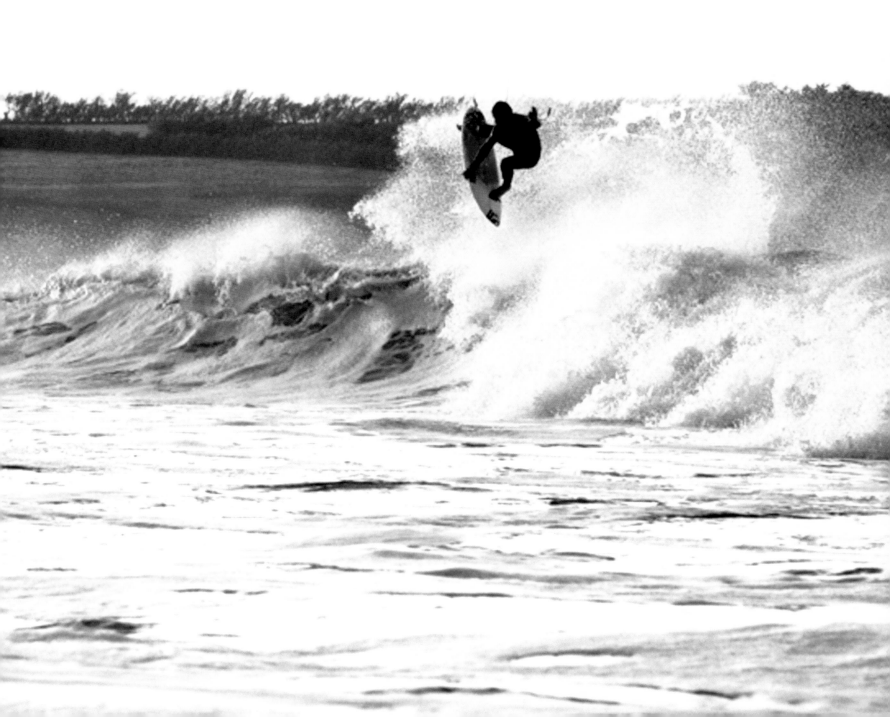

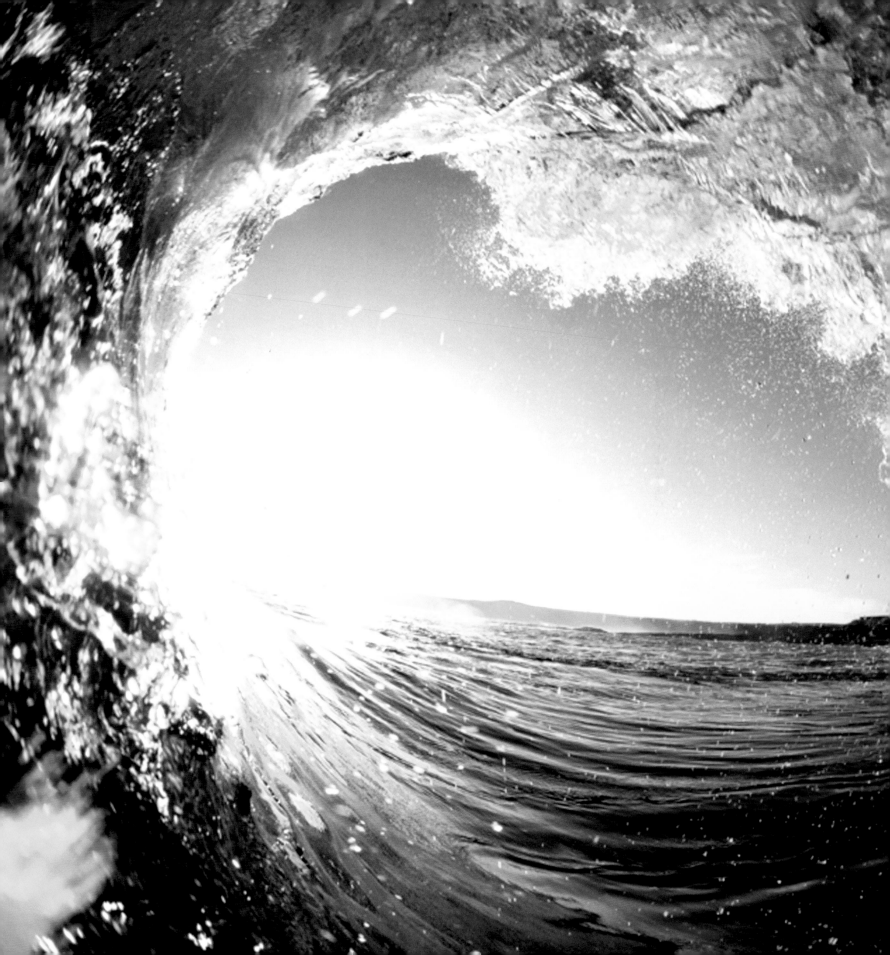

I've worked for Nike, Billabong, Quiksilver, Rip Curl, Analog and Gravis, to name a few surfing brands. I've also photographed for Siemens–that was a fun trip, flying to South Africa for a flow rider event they sponsored. Many of my nature photos have been used by the National Trust, the UK's best known nature and historical conservation charity, and the UK's national tourist agency, Visit Britain.

You must have so many incredible memories from your surf trips.

I have so many. The two that stand out in my mind were actually taking my two favourite water shots. One was in Mexico, with an injured Reuben Pearce. He paddled out with his foot strapped up, and I asked him what he was doing out in the water. He said, 'I'm just going to have a float around and see if any waves come my way'. Anyway, about 20 minutes later, we were both in the most perfect position ever; I was shouting at him "go go go!", and he paddled and stood up in a barrel with me in the perfect spot. I remember the whole transition felt smooth from taking off to pulling in and flying past me and then giving me a 'V' sign at the waters' edge as he prepared to exit the sea!

The other was in Morocco with the O'Neill crew. It was just Micah Lester and me, and we were with a group of surfers who all decided to go on to the next spot. We decided to stay at a little slab and wait for the tide to fill in, which seemed like a bit of a waste of time because even when we paddled out, it was still a little wobbly. Anyway, it was pretty much his first wave, and I was

out of position for the standard barrel shot, so I twisted myself around to snap a photo from behind him. I never knew it was going to come out so well! I remember thinking, 'we've just scored the shot of the trip!'

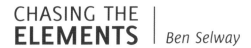

Where would you love to go to shoot some surf photos?

Well, I would say Thailand, but there isn't much in the way of surf there. However, Indonesia is like a second home to me, so it would have to be there. Probably Dane Reynolds, I'd say, somewhere in the Mentawais perhaps?

How do you get that highly sought after perfect water shot?

It's all about positioning and reading the waves. It almost becomes second nature guessing where to situate yourself. You first have to watch the waves from the shore for a little while and try and figure out where it is you're going to sit. Perhaps check the landscape around for some markers and roughly sit in that spot. It's a difficult question to answer, really, because there are various types of 'perfect water shot'. However, the gold standard barrel shot is about positioning yourself at the point it's going to barrel; you almost have to shoot blind when it comes to fish-eye lenses by holding your arm out from the face of the wave. Sometimes you score a good one, but more often you don't!

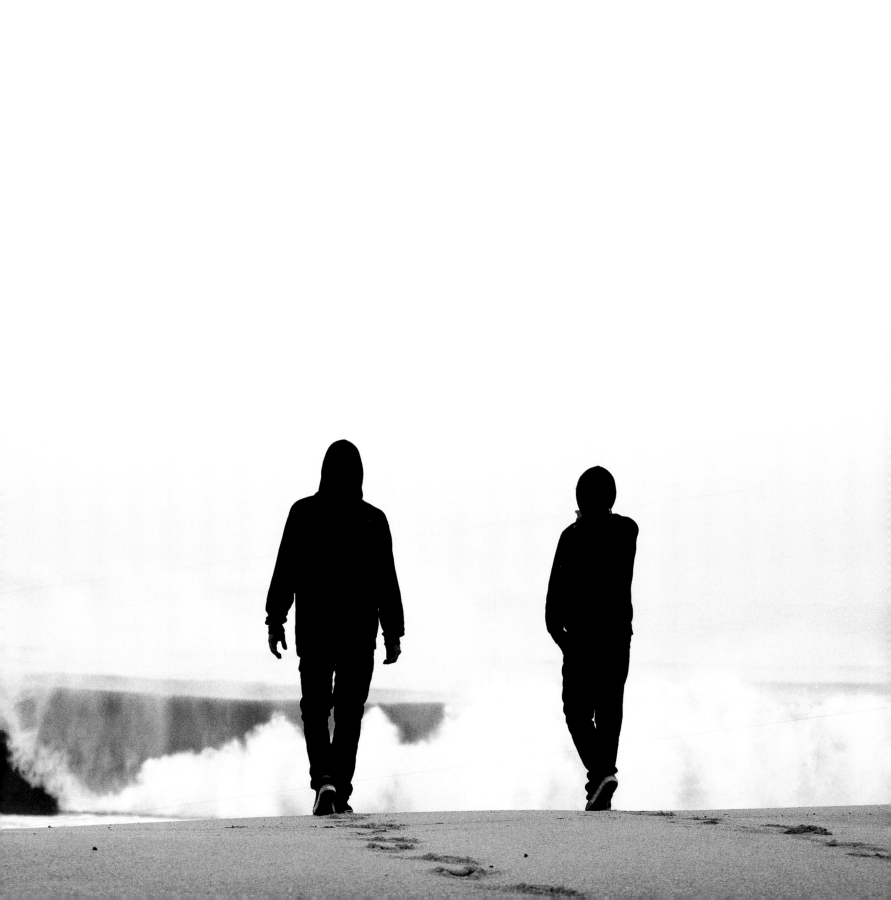

And your favourite surfer to work with?

Well, he's going to get a massive head, but pretty much the most photogenic surfer in the UK is a guy called Reubyn Ash. He has the whole game down in terms of style and flair. He's a photographer's dream to shoot with.

What kind of equipment do you use?

I use a Canon EOS 1DX for land and water photography. I used to have a 600-millimeter f4 lens, but it was too heavy and cumbersome to carry around. Besides, I feel surf photography has changed a little in the respect of capturing the scenery. Now I use a 70-200 2.8 lens plus a bunch of other lenses for portraits and landscapes. I use 5dmk3s for backup, but usually they're used for commercial work.

"When I've been away, I feel as though I have some perspective on the world again and that there's a lot more going on than just my little life in Cornwall."

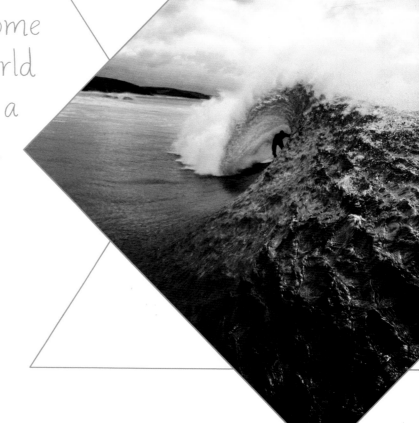

What have you learned from other cultures around the world?

I've learned so much. I have to say, my favourite place in the world is Thailand. The people are so warm and friendly, you rarely hear a raised voice, even in situations like heavy traffic. Generally they are the warmest and friendliest people I've encountered, and I definitely feel like a better person when I've been away. I feel as though I have some perspective on the world again and that there's a lot more going on than just my little life in Cornwall.

Which are the bits you enjoy the most about being abroad?

It sounds odd, but I really like airports! I like flying, especially when its Singapore Airlines and as long as I have a comfy seat, but most of all its everything to do with the climate—how light it is, how warm it is and how you can sit in your shorts and t-shirt late at night. The food is a big plus point as well. I particularly love Asia for all the above points. I certainly feel as though I could spend half of my life there.

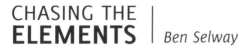

"In nature I feel alive with all of the wildlife around me. I love birds; they instantly bring a smile to my face."

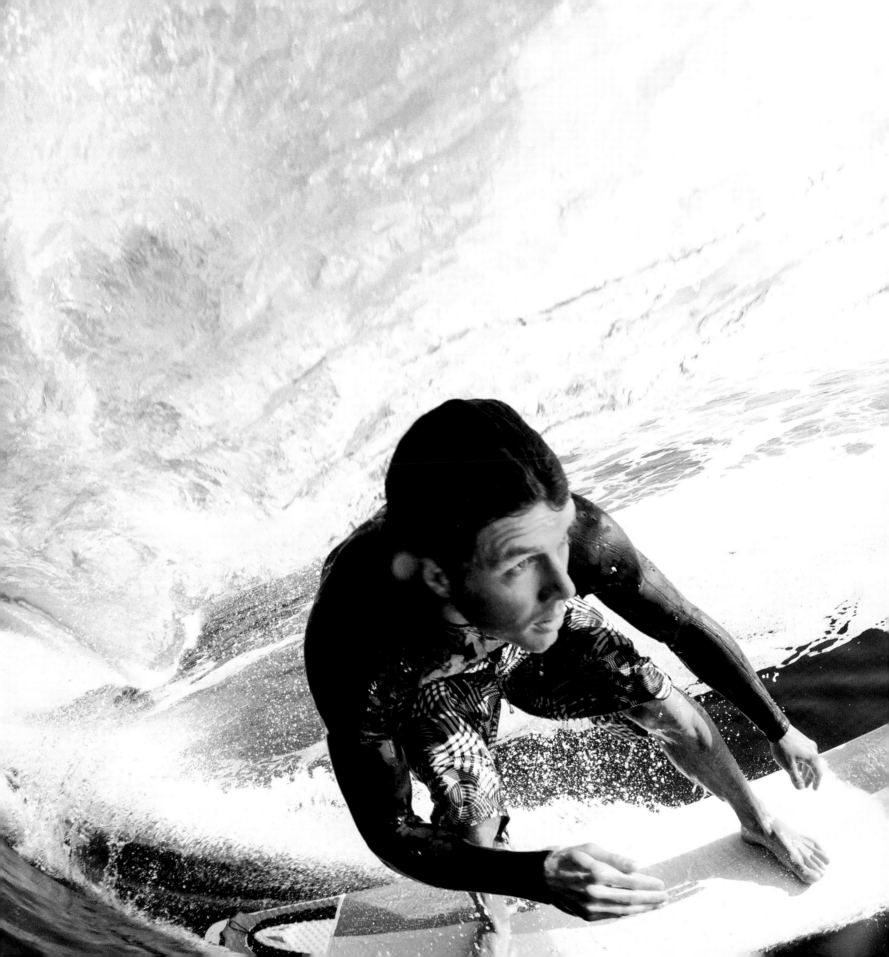

How does being in the great outdoors help you with your work?

I think without it, I wouldn't have a job. I wouldn't be sitting here answering these questions even. But seriously, I feel energised when I'm out in the great outdoors; it feeds my creativity almost. I can't explain it, it just does. I also feel the same about cities, though. I love the hustle and bustle of cities and the architecture and angles of the concrete. In nature I feel alive with all of the wildlife around me. I love birds; they instantly bring a smile to my face.

When's your favourite time to shoot?

That's an easy one to answer—low light, morning or afternoon, hot temperatures, slight offshore winds and a clean swell. It's the perfect recipe for fun waves.

What long-term dreams would you like to fulfil?

I guess the long-term plan is to base ourselves in Thailand for the winter months, so I'm only a short flight away from the rest of Asia!

SOCIAL
WEB WWW.BENSELWAYPHOTOGRAPHY.CO.UK
TWITTER @BENSELWAY1

CREDITS

CREDITS

Cover design,
layout and typesetting: Sannah Inderelst

Copyediting: Elizabeth Evans, Kristina Oltrogge

Graphics: © Thinkstock/iStock

Photographs:

Introduction &
Separator Pages © Ben Selway/Visit Britain
Pages: 6-17, 30, 31, 44, 45, 48, 49,
52, 57, 64, 65, 78, 79, 83-85, 100,
101, 118, 119, 122, 123, 138, 139,
158, 159, 174

Tia Blanco © Francis Juarez
Pages: 18, 19, 25
© Justin Jung
Pages: 20-24, 26, 29

Ryan Paul © Stephan Jende
Pages: 32-36, 38, 42
© Alessandro Giapaollo
Page: 40
© Nick Visconti
Page: 37

Brett Novak.................. © Kelton Woodburn
Page: 63
© Devende Photography
Pages: 50, 51, 54
© Kay Walkowiak
Page: 60
© Max Flick
Pages: 53,56,59

Luci Romberg © Emily Ibarra
Pages: 69, 70, 73-76
© Chad Bonanno
Pages: 66-68, 71, 72

Chad Kerley © Brandon Means
Pages: 86-98

Alex Rademaker © Liv Williams
Pages: 102-117

Easkey Britton.............. © Jelle Mul
Pages: 125-137

Herbert Nitsch © Andrea Zuccari
Page: 150
© Francine Kreiss
Page: 148
© Herbert Nitsch
Pages: 140-147, 149, 151, 153, 156

Ben Selway © Ben Selway
Pages: 160-173

BIG THANKS TO THE FOLLOWING CONTRIBUTING PHOTOGRAPHERS:

Justin Jung
www.jungphoto.com
Instagram @justinjjung
Twitter @JustinJung4

Brandon Means
www.beansvisuals.com
Twitter @brandonmeans

Chad Bonanno
www.chadbonanno.com
Twitter @chadbonanno

Stephan Jende
www.stephanjende.com
Twitter @sjendephoto

Jelle Mul
www.jellemul.com
Twitter @jellemul

Kelton Woodburn
www.keltonwoodburn.com
Instagram @woodburnphoto

DeVende Photography
www.devendephotography.com
Twitter @devendephoto

Kay Walkowiak
www.walkowiak.at

Andrea Zuccari
Facebook @shark155
Twitter @andreashark155

Francine Kreiss
Facebook @francine.kreiss.3
Twitter @francinekreiss

William Winram
www.williamwinram.com
Twitter @williamwinram

Emily Ibarra
www.ediphotoeye.com
Twitter @ediphotoeye

Nick Visconti
Facebook @nick.visconti

Ben Selway
www.benselwayphotography.co.uk
Facebook
Twitter @benselway1

Max Flick
Instagram @max_flick

Francis Juarez